Swinging Sixties

Fashion in London and beyond 1955–1970

Edited by Christopher Breward, David Gilbert and Jenny Lister

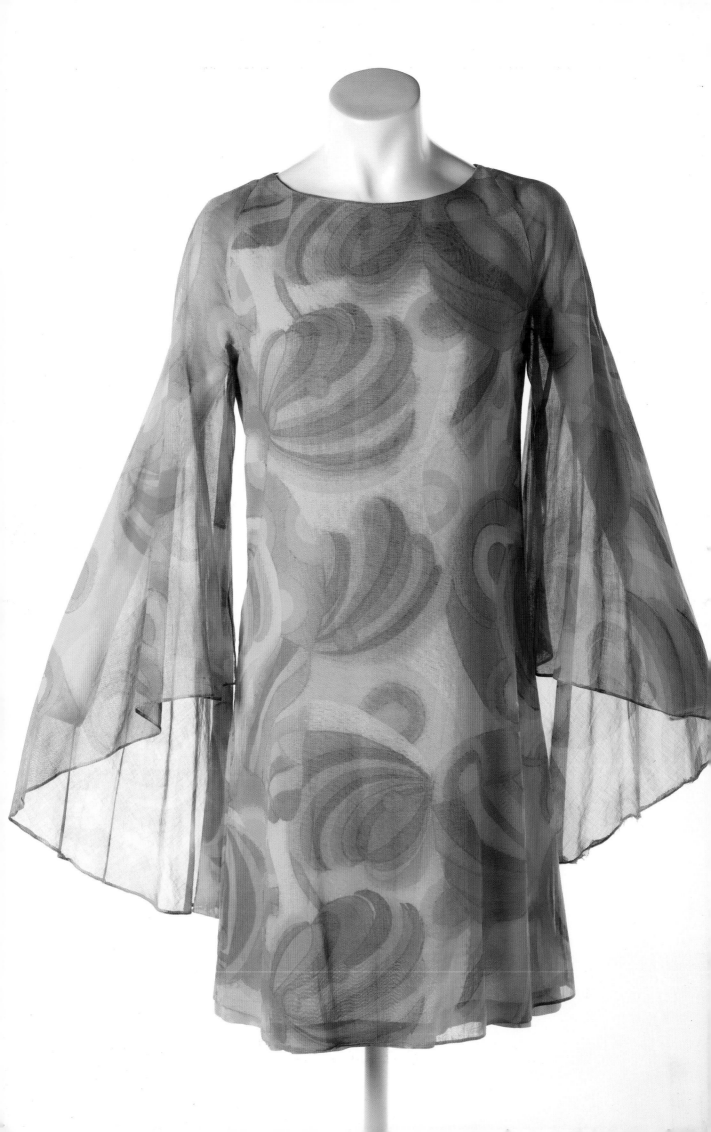

Swinging Sixties

Fashion in London and beyond 1955–1970

Edited by Christopher Breward, David Gilbert and Jenny Lister

V&A Publications

First published by V&A Publications, 2006
Victoria and Albert Museum
South Kensington
London SW7 2RL

Distributed in North America by Harry N. Abrams,
Inc., New York

ISBN-10 1 85177 484 X
ISBN-13 9781851774845

Library of Congress Control Number 2005935062

10 9 8 7 6 5 4 3 2 1
2010 2009 2008 2007 2006

V&A Publications
Victoria and Albert Museum
South Kensington
London SW7 2RL
www.vam.ac.uk

A catalogue record for this book is available from
the British Library.

Designed by Park Studio
New V&A photography by Richard Davis

Front cover Models wearing bib-topped trousers,
top and cap (left) and tunic dress and knee-length shorts
(right), all by Mary Quant. Photograph by John French,
1963 © V&A Images.

Back cover Dispo, paper minidress, 1967 (detail).
See p.53.

Frontispiece Georgie of Group 30 (retailed at Harrods'
Way In), dress. Printed cotton. British, 1967. Given by
Julia Parker. © Museum of London. See p.73.

Page 128 Mr Fish, printed corduroy suit, 1968 (detail).
See p.37.

Printed in Singapore

Contents

Acknowledgements ..6
List of contributors...7

Introduction Christopher Breward ..8

Kaleidoscope: Fashion in Sixties London Jenny Lister22
Mary Quant..40

'Brave New London': Architecture for a swinging city Bronwen Edwards42
A New London..56

'I think they're all mad': Shopping in Swinging London Sonia Ashmore58
The Boutique Look...78

Myths of the Swinging City: The Media in the Sixties Pamela Church Gibson80
Cover Appeal ...100

Out of London David Gilbert ...102
London on Tour ..118

**'Goodbye Baby and Amen': A Postscript for the
Swinging Sixties** Christopher Breward ..120

Notes...124
Bibliography...125
Index...126

Acknowledgements

The editors, contributors and publishers would like to thank the Economic and Social Research Council and the Arts and Humanities Research Council for their financial support. The book and its accompanying exhibition were completed as part of the ESRC/AHRC 'Cultures of Consumption' Programme (project RES-143-25-0038).

The editors would like to thank the following at the V&A, in particular Richard Davis for his excellent photography; and Mary Butler, Vicki Coulson, Lara Flecker, Lynda Hillyer, Ken Jackson, Lucy Johnston, Suzanne Lussier, Susan North, Linda Parry, Sue Prichard, Carolyn Sargentson, Suzanne Smith, Sonnet Stanfill, Claire Wilcox, Christopher Wilk, Monica Woods, and the staff of the National Art Library and the Archive of Art and Design.

Thanks are also due to the copy-editor, Catherine Blake, and the designers, Park Studio; Oriole Cullen and Edwina Ehrman of the Museum of London; Rosemary Harden of the Museum of Costume, Bath; Katherine Baird, Sandra Holtby and Robert Lutton of the London College of Fashion; Sebastian Wormell of the Harrods Archive; and Marit Allen, Sylvia Ayton, Anne Marie Britton, Rachel Cooke, Marion Foale, Felicity Green, Roy Orbach, Sally Tuffin, Charlotte Prichard and Emily Prichard.

Contributors

Christopher Breward is Deputy Head of Research at the V&A Museum and a Professorial Fellow at London College of Fashion, University of the Arts, London. He is co-director, with David Gilbert, of the ESRC/AHRC 'Cultures of Consumption' Research Project: 'Shopping Routes: Networks of Fashion Consumption in London's West End 1945–1979'. His recent publications include *Fashion* (2003) and *Fashioning London* (2004). He was also co-curator of the Museum of London exhibition 'The London Look' (2004–5).

David Gilbert is Reader in Human Geography at Royal Holloway, University of London, and a specialist in the history of twentieth-century London. He is co-director, with Christopher Breward, of the ESRC/AHRC 'Cultures of Consumption' Research Project: 'Shopping Routes: Networks of Fashion Consumption in London's West End 1945–1979'. His recent publications include *Imperial Cities* (with Felix Driver, 2003) and *Geographies of British Modernity* (with David Matless and Brian Short, 2003).

Jenny Lister is a curator of fashion at the V&A Museum. Previously, she worked as a curator at Kensington Palace and the Museum of London. She has written and lectured on many subjects including royal dress in the eighteenth century and London designers in the 1920s.

Sonia Ashmore is a design historian and member of the 'Shopping Routes' Research Project. She is a Research Fellow at the London College of Fashion and has recently completed a new study of Liberty & Co. in the context of oriental trade.

Pamela Church Gibson is Reader in Cultural & Historical studies at the London College of Fashion. She has published widely on film, fashion, fandom, history and heritage and has co-edited three anthologies, including *The Oxford Guide to Film Studies* (1998) and *Fashion Cultures: Theories, Explorations, Analyses* (2001).

Bronwen Edwards is a Research Fellow in the Geography Department at Royal Holloway, University of London. She is a member of the 'Shopping Routes' Research Project, conducting research on retail architecture, urban planning and the 1953 Coronation parades. She has previously written on West End shopping cultures of the 1930s.

Introduction

CHRISTOPHER BREWARD

In a decade dominated by youth,
London has burst into bloom. It swings;
it is the scene. This spring, as never
before in modern times, London is
switched on. Ancient elegance and
new opulence are all tangled up in
a dazzling blur of op and pop. The
city is alive with birds (girls) and beatles,
buzzing with minicars and telly stars,
pulsing with half a dozen separate
veins of excitement. [1]

On 15 April 1966 the American weekly
news magazine *Time* published a special
edition celebrating 'London: The Swinging
City'. Perhaps more than any other artefact
from the mid-1960s it expressed all that
was distinctive about the culture of the British
capital. The cover illustration designed by
Geoffrey Dickinson captured what would
become the clichéd signifiers of an era.
Against a Union Jack backdrop, the city's
architecture is indicated by Big Ben and
a suburban bingo hall – a celebration of
the unique and the ordinary. Between them,
the neon of a cinema sign advertises the
latest Michael Caine film *Alfie*. Recently re-
designed road signage directs a selection
of vehicles, from a red Routemaster bus,
through to a Jaguar E-type sportscar, a
Mini Cooper and a Rolls Royce. A range
of characters inhabits this lively landscape
– an aristocratic couple in black tie play
roulette, a photographer aims his camera
from the entrance of a discotheque, a pop
singer in a 'Who' T-shirt with Union Jack
'British Made' badge and sunglasses
serenades from the front, and even Prime
Minister Wilson in trademark Gannex raincoat,
pipe in mouth, waves a flag in the background.
But at the centre of it all are the fashion-
conscious young who were the real focus
of journalistic curiosity. With their striking
Op-art minidresses, dandified suits and
childlike poses these creatures are the key
subjects of the caricaturist's brush.

In many ways *Time*'s 'Swinging City' issue
set one of the most enduring templates for
subsequent understandings of the 'Swinging
Sixties', at least as an archetype. Fashion
innovation and pleasurable consumption
were at its heart, but it also incorporated
a set of relationships between the values
of old and new Britain, and between London
and the rest of the world. Its material qualities,

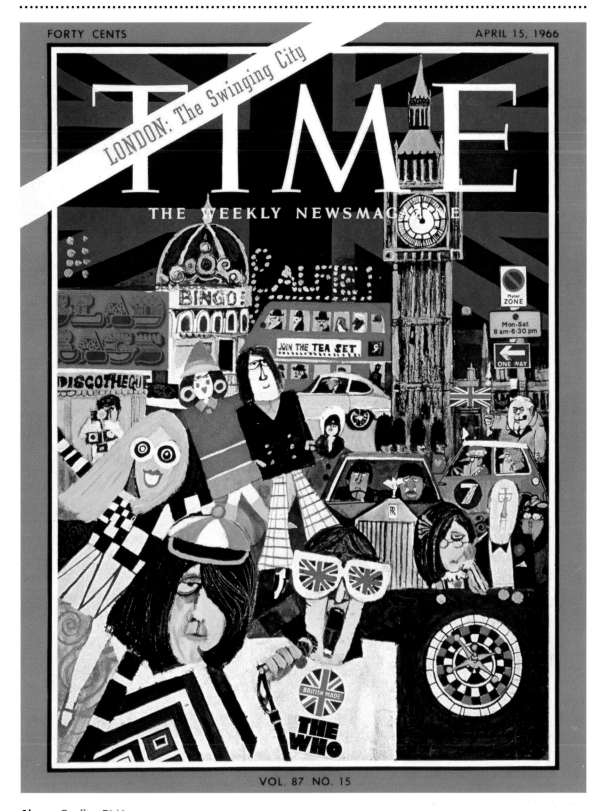

Above Geoffrey Dickinson,
Time magazine cover.
15 April 1966. Time
Magazine © 2005 Time Inc.
Reprinted by permission.

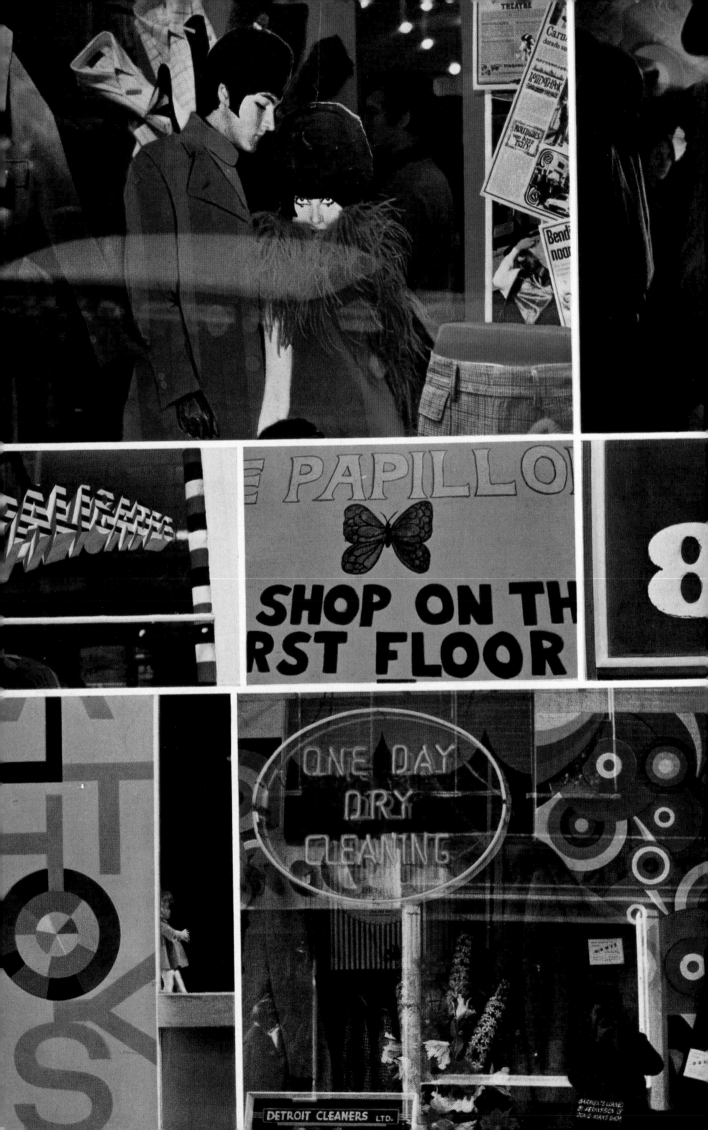

NO

TO WALTON STREET
DIVERSION

THIRD PACESET

MALE
WEST
ONE

W. 1.

manifested through clothing, photography, film and music, set up deliberate contrasts between tradition and modernity, and its general tone was bright and brash. *Time* seemed to record a new irreverent spirit in British social attitudes that ushered in a meritocratic sensibility and ignored the prejudices of a hidebound establishment. In turn reactionary critics such as Christopher Booker argued that this youthful world was too dominated by the attitudes of the 'neophiliacs' – those in love with newness itself, who paid scant attention to the realities of life beyond their solipsistic metropolitan concerns.[2] He considered the whole swinging scene to be a self-congratulatory mirage – and it could be argued that the *Time* article was part of the same myth-making process. The political right was not alone in holding this opinion. At the close of the decade even John Lennon famously claimed that 'the whole bullshit bourgeois scene is exactly the same, except that there are a lot of middle-class kids with long hair walking around London in trendy clothes... nothing happened except that we all dressed up.'[3]

By announcing the existence of 'The Swinging City', *Time* both named a cultural phenomenon and simultaneously sealed its fate. From the distant vantage point of New York, its observations could claim the objectivity of the impartial witness, but at the same time they suffered from the inevitable problem of translation and the distortion that second-hand experience often brings. The magazine was not alone in focusing on London as the cradle of a new outlook expressed through dress, shopping and popular culture. The *Daily Telegraph* colour supplement had run a feature on 'London: The Most Exciting City' a year before, focusing on its attractive young women with their supposedly relaxed attitude to sexual morality and self-presentation.[4] A year later in January 1967 the revolutionary Italian designer and critic Ettore Sottsass produced a spread of images in the architectural magazine *Domus* that captured the kaleidoscopic effect of the signs and window displays associated with the new London boutiques. Whether the visions they offered were a reflection of real changes or part of the myth-making process is perhaps less important than their pervasiveness, not just in journalism, but also in films, novels, paintings, songs and poems that all presented versions of the same swinging theme. However,

Previous pages Ettore Sottsass, 'Memoires di panna montata', Domus magazine. January 1967, pp.30–1.

Opposite Mary Quant, pinafore dress. Natural hessian with silk trim. British, designed 1965 (remade 1973). Given by Mary Quant. V&A: T.110–1976.

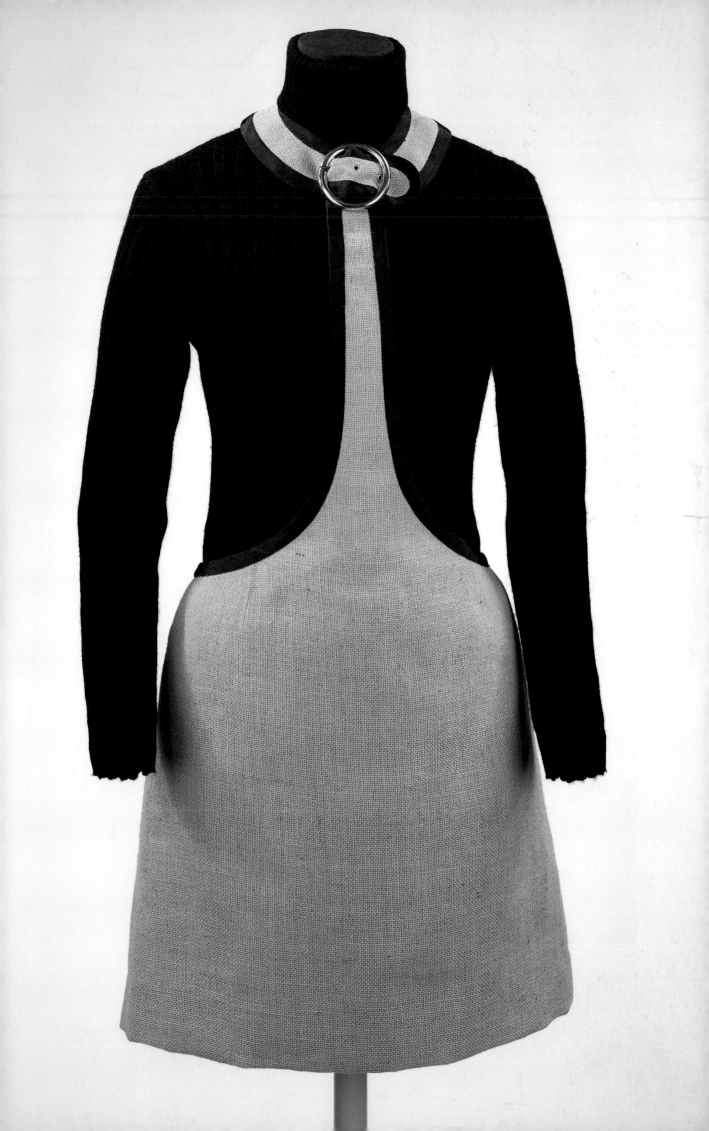

running through this was a powerful sense that the design, retailing and wearing of fashionable dress played a pivotal role in grounding such dreams in everyday experience.[5]

In the surviving clothes of the time, we have physical evidence of the ways in which the Swinging Sixties were experienced on the body and in space. Looking at actual garments takes us beyond the iconic imagery of *Time*, and can contradict the shifting surfaces of photographs and films, the questionable objectivity of contemporary writing or the hazy and nostalgic recollections of personal memory. Sometimes they also confirm these very things. But in all cases they challenge the historian or the casual observer to engage with the period through a consideration of what it felt like to change appearances with the times, to enjoy an unprecedented freedom of movement and the strange sensations of new textures, to appropriate the 'look'. In their very materiality such items constitute a complex version of the Swinging Sixties that is in some ways as convincing a record of the times as the visual clichés of the *Time* cover. We could, for example, juxtapose Dickinson's impression

with a hessian dress produced by the quintessential Swinging London designer Mary Quant in 1965 (see p.13). With its short skirt and deceptively simple line, utilizing an extended belt to form a halter-neck fastening with a large buckle worn high on the chest over a polo-neck sweater, the ensemble points to the multi-faceted version of fashionable femininity promoted by Quant and her generation. It was clearly easy to wear and maintain, well adapted to the increased pace of modern city living. But stylistically it moved beyond comfort and practicality to suggest bohemian revolt (in its emphatic use of black), graphic sophistication (in its play with textures, interesting shapes and bold accessorization) and schoolgirl innocence (the dress, whose form tends to narrow the hips, was worn with a schoolboy cap in matching linen material). It tells us much more about the lifestyles and aspirations of the King's Road habitués than *Time*'s stereotypes.

As Jenny Lister's chapter makes clear, Quant was not the only designer with the creative and entrepreneurial abilities to shape a radicalized fashion culture. With her peers, who included John Bates, Foale and Tuffin and later Ossie

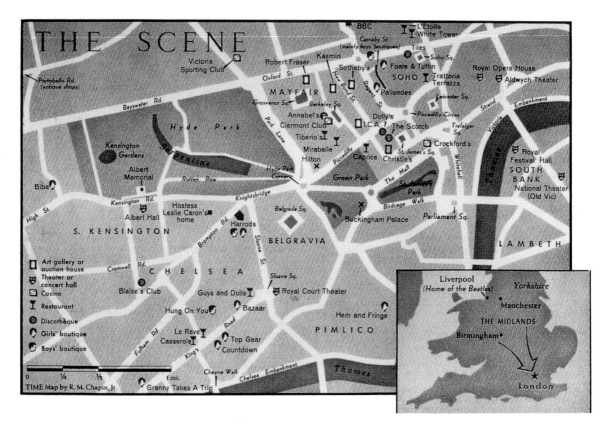

Above 'The Scene', map, *Time* magazine. 15 April 1966, p.41a. Time Magazine © 2005 Time Inc. Reprinted by permission.

Clark, she succeeded in overturning the repressive attitudes formerly associated with English dressing by presenting a variety of competing looks. But this was neither achieved overnight, nor in a vacuum. It is often a shock to recall that Quant's first boutique was opened in 1955, eleven years before *Time* announced London's swinging status to the world.[6] The new clothes culture associated with London in the 1960s built on the foundations of the previous decade and even earlier.[7] In several respects its qualities reprised the tenets set down by the Pop artist Richard Hamilton in 1957 (as guidelines for the recently established Independent Group). It was, like the painting scene that preceded it, 'popular, transient, expendable, low-cost, mass-produced, young, witty, sexy, gimmicky and glamorous'.[8] And it is no coincidence that both the new art and fashion scenes were reliant on the support of institutions such as the Royal College of Art, whose enlightened attitude to training and education first took hold in the late 1950s. As far as garment design and manufacture are concerned, it can also be argued that the innovations of Quant and her followers would not have been possible without the existing infrastructure and skills of a London rag trade

that had been growing for almost two centuries.[9] Indeed there are as many connections between Quant's work and the work of a preceding generation of designers (who collectively formed the Incorporated Society of London Fashion Designers, or Inc. Soc.) as there are differences. For example, the pioneering experimentation with fastenings and economical use of construction elements that characterized Inc. Soc.'s output for the wartime Utility scheme pre-empted Quant's use of similar motifs by several years.[10] And many 'swinging' designers were as interested in the repertoire of traditional British fabrics and tailoring techniques as they were in the potential of current materials such as plastic and paper. The old always informed the new.[11]

An examination of the retail scene in the 1960s does permit a less cautious interpretation than that applied to the clothing itself – one that recognizes the decade's claim to be innovative and challenging.[12] As Sonia Ashmore's study suggests, from Bazaar to Biba, the striking window displays and interiors of London's boutiques altered the atmosphere of shopping districts in significant ways and undoubtedly

informed new attitudes towards the buying and wearing of clothes amongst the younger generation. But, once again, these changes need to be viewed as part of a longer continuum. Much recent work on urban space and identity has put forward a reading of the modern city as a place of networks, flows and connections, where social, aesthetic and cultural meanings are constantly in flux – and Swinging London in all its mythic complexity can only be understood this way.[13] A good starting point is the map of 'The Scene' that *Time* supplied in its special issue (see p.14). Here the old heart of Empire with its palaces, parks and ceremonial routes is overlaid with a new geography of shopping outlets, restaurants and discotheques. The King's Road and the area around Carnaby Street provide alternative centres of gravity to the traditional markers of political and social power in Westminster and Belgravia. Yet, interspersed between Hung On You and Foale & Tuffin are the survivors of an older 'aristocratic' leisure culture, such as Christie's and Crockford's, rejuvenated for new times. It is clear that for Swinging London to succeed a certain degree of acquiescence was necessary from the landed classes. For all the talk of a supposedly meritocratic new order,

it is instructive to recall how many young 'honourables' were the proprietors or backers of cutting-edge boutiques, trattorias and galleries. *Time*'s map makes these complex class relationships plain for all to see.[14]

In her chapter on urban change, Bronwen Edwards reminds us of the degree to which the retail landscape that constituted Swinging London was just one element in a process of post-war metropolitan transformation. Although it was encouraged by urban planners and government bureaucrats, it was put into place by architects, designers, property speculators, shop owners and the population of London itself. It was a process that altered the face of the city in as radical a manner as the Blitz, and the magnitude of its effects demands that the fashions of the 1960s, rather than simply being celebrated for their quirky and nostalgic appeal, should also be viewed as part of a broader mechanism for social and material renewal.

The shifting fortunes of Carnaby Street are a perfect illustration of this theme and can be read on several levels. In many ways, this small thoroughfare stands as a symbol of the

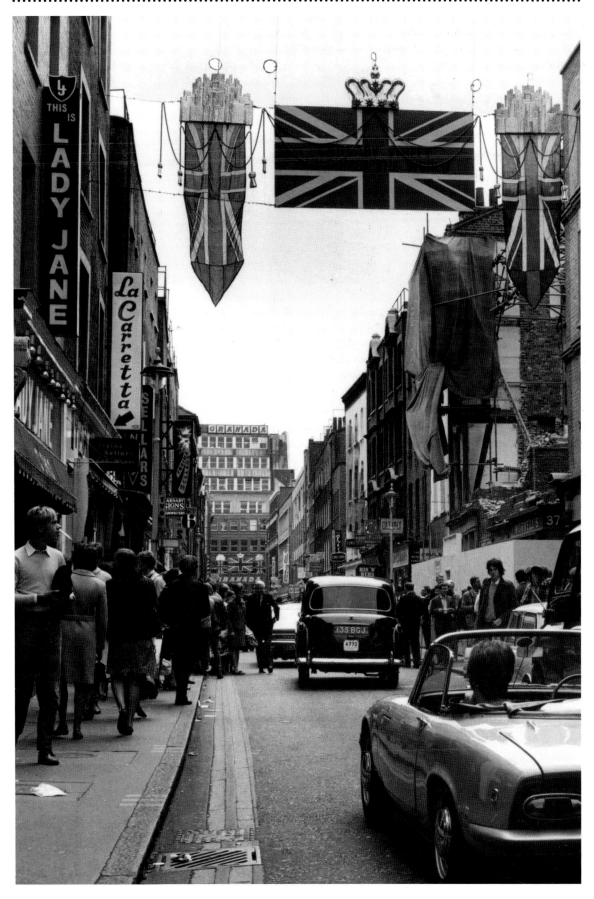

Above Henry Grant, Carnaby Street Scene, c.1968 © Museum of London.

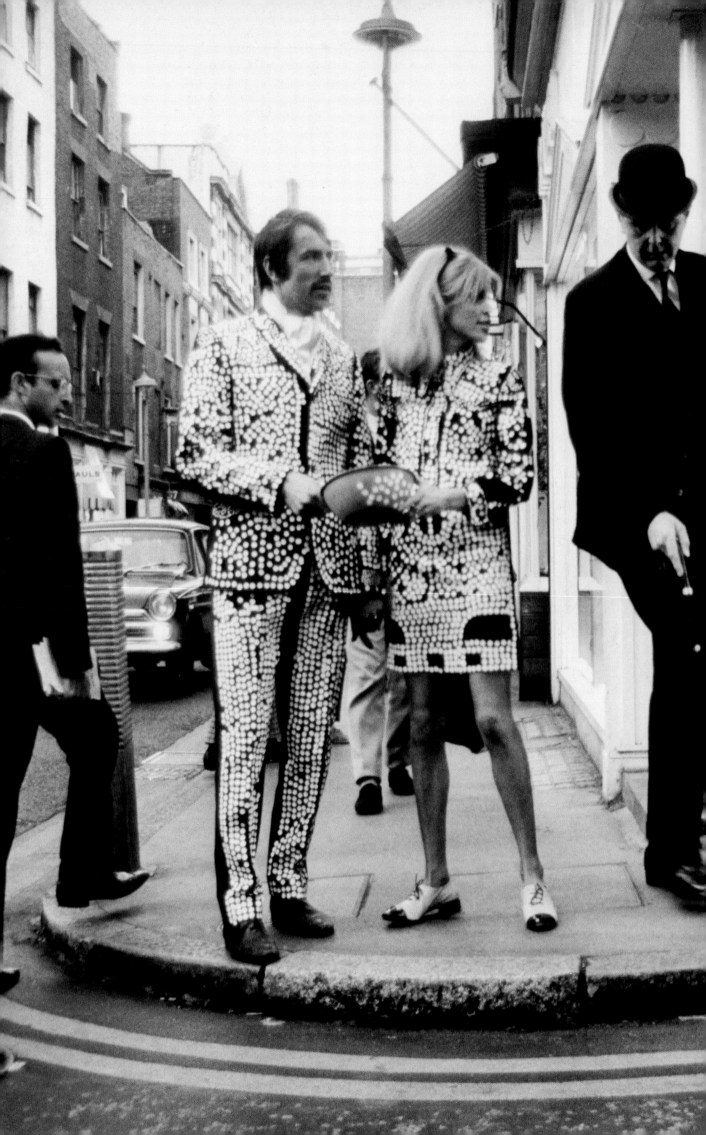

fashion-led changes that affected the whole of London in the period. In the 1950s it was the central shopping area of an artisanal backwater, shadowing Regent Street but bearing little relation to the elite and fashion-focused character of its glamorous neighbour. Some low-grade garment manufacturing took place in the upper storeys of buildings, in the permeable domestic settings that functioned as out-sourcing workshops for the local rag trade. But in essence Carnaby Street offered its shoppers the stationer, baker, confectioner, tobacconist, ironmonger and hairdresser that would have featured in any down-at-heel urban high street from the 1880s onwards. Vince was the only nearby clothing store, offering outré styles to a cliquey clientele of chorus boys and minor sports celebrities associated with the demi-monde of the West End's still criminalized gay scene.[15] By 1965 the number of garment workers in the upper floors of the street had doubled, while the floors below were now taken up by the menswear boutiques of John Stephen and others. These incomers, building on the reputation established by Vince, transformed the district, almost obliterating older practices and traces.[16] Only five or six years later, Carnaby Street had changed its nature again.

Opposite Ian Grey and his wife, owners of Gear in Carnaby Street, dressed as a Pearly King and Queen, collecting for Oxfam, 1966 (detail). Courtesy of Philip Townsend.

Now pedestrianized and full of souvenir emporia selling to tourists, its glory days were over. The cutting-edge outlets had re-established themselves elsewhere, and with fashion production starting to move off-shore the close relationship between local garment manufacturing and retail that characterized Britain's swinging heyday had started to break down. Yet, as Sonia Ashmore argues, the boutiques of Carnaby Street provided an enduring series of prototypes that represented both the best and the worst of 1960s entrepreneurship, and their contributions were certainly nothing if not attention-grabbing.

While it lasted Carnaby Street formed an important conduit for several processes that moved beyond the realms of fashion, capturing the general sense of rapid social and material change that has come to colour our understanding of the period. Its history as a focus for modes of subcultural dressing that challenged class and sexual stereotypes places it at the centre of debates around social emancipation and identity politics.[17] The new fashion businesses that transformed its atmosphere echoed shifting practices in the British rag trade. As a magnet for tourists,

its Union Jack festooned façades presented a new face of Britishness to the world in the context of a period marked by its post-imperial attitudes. This promotional endeavour was aided by the proximity of so many new advertising agencies, publishing houses and media headquarters whose output, as Pamela Church Gibson states, did so much to direct the idea of Swinging London into the popular imagination. Its transformation from a late nineteenth-century slum to a pedestrianized 'destination' marks it out as a typical example of modern town planning. And beyond all of this, Carnaby Street functioned on a more mundane basis as a route frequented by the old as well as the young, by office workers as well as tourists, and by the ordinary shopper as well as the 'dedicated follower of fashion'.

Carnaby Street was not the only focus for the fashionable young in 1960s London and its story is repeated across the city and further afield: in Mayfair, Chelsea and Kensington, and, as David Gilbert's chapter on the Swinging Sixties phenomenon beyond the capital shows, in Paris, New York and Liverpool, and even in Nottingham. In its leading article, *Time* was keen to show the way that swinging culture worked in different ways in different places in the city. Adopting the format of a storyboard for an imaginary film, the writer presented five different 'scenes': an aristocratic evening – with the son of a peer, starting at Jack Aspinall's Clermont Club, an exclusive casino situated in an eighteenth-century town house in Berkeley Square, and ending in Annabel's nightclub nearby. A Saturday afternoon's shopping – in Chelsea and the Portobello Road, taking in the Guy's and Doll's coffee bar in the King's Road in the company of pop singer Mick Jagger, television presenter Cathy McGowan and a teenager in a black and yellow PVC miniskirt. A Chelsea lunch party – in Le Rêve Restaurant with actors Terence Stamp and Michael Caine, model Jean Shrimpton, hairdresser Vidal Sassoon, photographer David Bailey and tailor Doug Haywood. And an early evening cocktail party – at Robert Fraser's Mayfair art gallery, attended by 'panda-eyed' socialite Jane Ormsby Gore in a red Edwardian jacket and ruffled lace blouse, designer Pauline Fordham in a silver coat and starlet Sue Kingsford in a pink trouser suit that revealed her naked waist. The final scene focused on a very star-struck dinner with Marlon Brando, Roddy McDowell,

Terry Southern, Françoise Sagan, Barbra Streisand, Margot Fonteyn and Warren Beatty in the Kensington home of Leslie Caron. After an excellent meal 'of chicken, claret and Chablis', the international jet-setters 'danced till dawn'.

These scenarios, like the cover illustration that went with them, self-consciously tick all of the Swinging Sixties boxes with their mix of the elite and the popular, the establishment and the avant-garde and their obsession with celebrity, with fabulous clothes, ephemeral and diverse settings and with the conspicuous pursuit of pleasure for its own sake. The tone of *Time* may well have been satirical, but the world it described offered a range of new self-fashioning possibilities that were in essence liberating. And, although much of the associated imagery was a constant replay of metropolitan myths with little direct material relevance for the lives of much of the British population, there is no doubting that its content marked a tangible mood that was exciting and challenging; one that certainly continues to fascinate subsequent generations with its shiny surfaces and fresh attitudes.

In recognition of such tensions, this book, written 40 years on from the original events, draws on the collections of the V&A to reflect on some of the claims made about the Swinging Sixties at the time, without wholly debunking them. Benefiting from recent scholarship in social history and consumption studies while also looking to surviving objects for complementary evidence, it unpacks the myths, but it also re-emphasizes the importance of the period, giving retrospective credence to *Time*'s final assertion:

The London that has emerged is swinging, but in a far more profound sense than the colorful and ebullient pop culture by itself would suggest. London has shed much of its smugness, much of the arrogance that often went with the stamp of privilege, much of its false pride – the kind that long kept it shabby and shopworn in physical fact and spirit. It is a refreshing change, and making the scene is the Londoner's way of celebrating it.[18]

Kaleidoscope

FASHION IN SIXTIES LONDON
JENNY LISTER

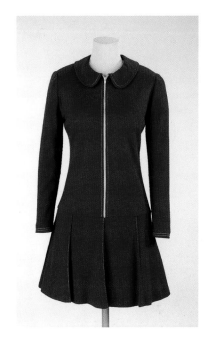

Right Mary Quant, dress. Wool jersey. British, 1967. Given by Mary Quant. V&A: T.353–1974.

Opposite London designers by the Thames. 1966 © Norman Parkinson Ltd/Fiona Cowan.

Instantly recognizable, the definitive image of 1960s fashion is encapsulated in a jersey minidress designed by Mary Quant. Quant's youthful clothes have come to represent the look of the generation born after World War II, who grew up in an environment of increasing affluence and freedom. But fashion in the 1960s was infinitely more complicated: a kaleidoscope of influences from the past and the future, as well as from other cultures, informed the work of the designers who responded to the explosion in the market for exciting new clothes. Mary Quant herself recognized that her offbeat designs were simply part of a wider social change; her clothes just 'happened to fit in exactly with the teenage trend, with pop records and espresso bars and jazz clubs'.[1]

Quant was one of many entrepreneurs who identified with the frustration of young adults unable to find the unfussy, casual clothes they wanted in the shops in the late 1950s. At this point fashion for women was led by the tiny minority who could afford to be dressed in Paris. As Sonia Ashmore suggests, London couturiers – such as Norman Hartnell and Hardy Amies – struggled to compete with the Paris fashion houses, but they had built up a faithful following by catering to the typical British upper-middle class taste for high quality, practical tailored suits and pretty, feminine gowns for the formal occasions of the London Season.[2] The fashionable silhouette was based on a well-groomed, corseted figure, completed with carefully chosen accessories. Barbara Hulanicki found that 'the shops in England... were full of matronly clothes – either direct copies of Paris models or deeply influenced by the Paris collections'.[3]

Smart ready-made suits and dresses were made by firms such as Jaeger, Susan Small and Polly Peck, for women who could not afford a made-to-measure wardrobe. The young *Vogue*-reading debutante, newly launched into adult society, would require a tweed suit, an office dress, a cocktail dress and country separates. A crisp printed-cotton Horrockses dress was a popular summer basic, combining quality and practicality with cheerful, feminine fabric designs. In a 1960 *Queen* fashion feature 'Beat the Beatniks – eligible clothes for debs', Norman Parkinson photographed pin-neat suits and shirt-waisters on aloof models, 'beating the beatniks at their own

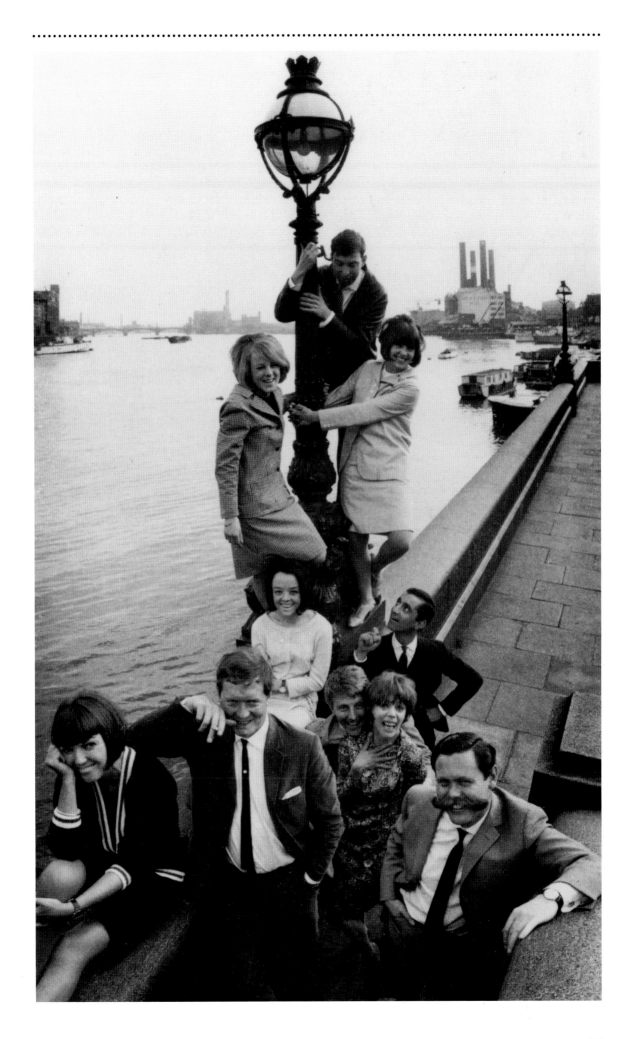

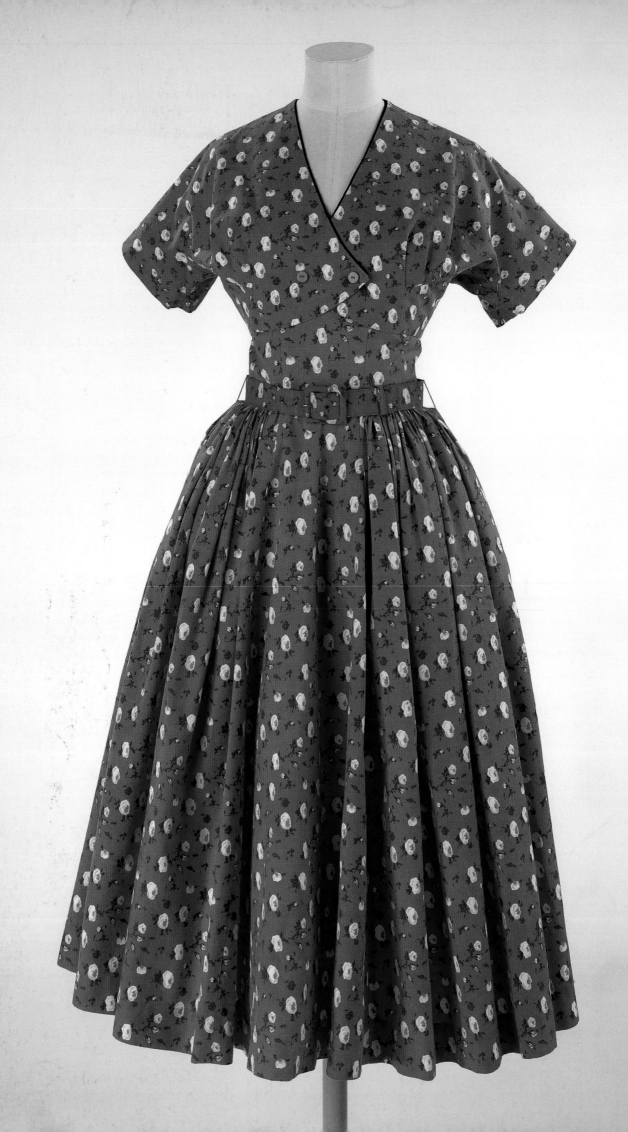

game of how to be *avant-garde*.[4] But the days of the deb were numbered: in the background, blurred party-goers with loose hair, baggy jumpers and knee-boots wear the new uniform of youth rebellion.

Clothes for professional men in the 1950s were deeply conservative, and only varied in quality of cloth and small details such as number of buttons and pockets. The wealthy international elite went to Savile Row tailors for bespoke suits, while cheaper made-to-measure suits were available from high-street chains, such as Burtons, and department stores. Casual clothes imported from the US were slow to be accepted. However, the teenage market exemplified by the style of the Teddy Boy had broken new ground, and it was more acceptable for men to be concerned with their appearance and dress for effect.[5] By 1958, a new Italian style came in, with short jackets and narrow trousers, a look that was appropriated by a small group of teenage dandies who came to be known as 'modernists' because of their taste for modern jazz.[6]

Mods took inspiration from many sources – American teenage fashions, R&B music, French films, city gent tailoring and sportswear. They adopted existing garments and combined them in a new way. But the Mods, constantly customizing and making up their own designs, were also responsible for crazes and ever faster changing fashions. As Mary Quant pointed out: 'It is the Mods... who gave the dress trade the impetus to break through the fast-moving, breathtaking, up-rooting revolution in which we have played a part.'[7]

John Stephen was the first to take advantage of the potential for interesting, morale-boosting clothes for men. Stephen had worked at Vince, the forerunner to the Carnaby Street phenomenon, selling comparatively outrageous clothes to 'theatrical' customers, and in 1957 Stephen set up his own shop, His Clothes, in a one-room boutique in Beak Street. One customer, Richard Barnes, recalled that:

In most men's outfitters at that time you'd see lines of jackets or trousers or something and they'd all look the same. Some were black, some were dark black, others were jet black and if you wanted to be a little extrovert you could risk a black one with, wait

Opposite Horrockses, dress and jacket. Printed cotton. British, c.1957. Worn and given by Mrs Elizabeth Payze. V&A: T.639&A–1996.

Right Norman Parkinson, 'Beat the Beatniks', *Queen*, 2 February 1960. 'Black and grey pin-striped cardigan wool suit. By Estrava, 14 gns, at Jay's. Black satin pill box hat with a black and brown grosgrain ribbon, by Chez Elle, £4 19s.11d. at Liberty. Striped suede handbag, 9 gns. at Bazaar.'

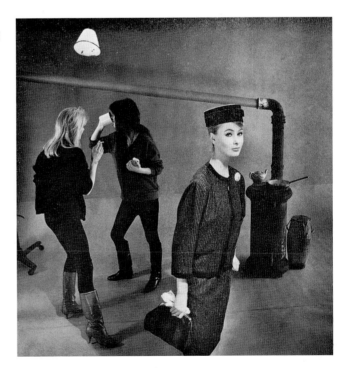

for it, a grey speckle running through it. But in His Clothes not only were there fantastic daring colours, but there were loads of different styles and fabrics.[8]

John Stephen offered the latest essentials – denim shirts, T-shirts, moccasin shoes, reefer jackets – made reasonably well and fairly priced. His stock changed constantly, and continued to move men's fashion in new directions, towards eclecticism and historic revivals. John Stephen's success attracted many imitators, including Lord John, a shop that opened in Carnaby Street in 1963. Lord John was owned by brothers Warren and David Gold, who had begun their venture into men's wear while running a stall in Petticoat Lane market. Their heavy blue woollen trenchcoat of 1968, topstitched in white, reflects the swing back towards a wider, 1940s outline, but was made of coarse fabric, and 'not exactly built to last a lifetime'.[9]

While middle-class and working-class teenagers were discovering Soho as a source for the latest fashions, the Royal Borough of Kensington and Chelsea was where those from more privileged backgrounds spent money on clothes. When Mary Quant opened Bazaar in 1955 the King's Road was lined with shops supplying the needs of the local residents, a mixed society including wealthy aristocrats, young professionals, artists and actors. One of them was Alexander Plunket Greene, who was at Goldsmith's College of Art, studying illustration, at the same time as Mary Quant was training as an art teacher. Despite their different social backgrounds, Plunket Greene and Quant found they had much in common, including an unconventional taste in clothes and a taste for the exciting, anti-establishment lifestyle of the Chelsea set. Together with Archie McNair, they formed a highly creative partnership and set up their first boutique selling '…a *bouillabaisse* of clothes and accessories… sweaters, scarves, shifts, hats, jewellery, and peculiar odds and ends'.[10]

Initially Bazaar sold clothes sourced from London wholesalers and art school students, but after a 'mad' pair of Quant's house-pyjamas was featured in *Harper's Bazaar*, and bought by an American manufacturer, she decided to make up her own ideas for the shop. Her designs used traditional fabrics,

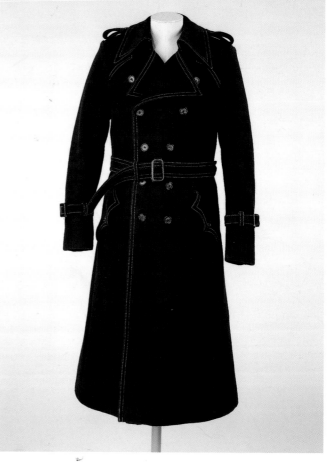

Above Bazaar label, from pinafore dress. V&A: T.219–1995.

Right Lord John, coat. Wool. British, c.1968. Given by Mr David Shilling. V&A: T.75&A–1983.

Opposite Bazaar (Mary Quant), pinafore dress. Wool. British, 1961. Worn and given by Jasmine Grassie. V&A: T.219–1995.

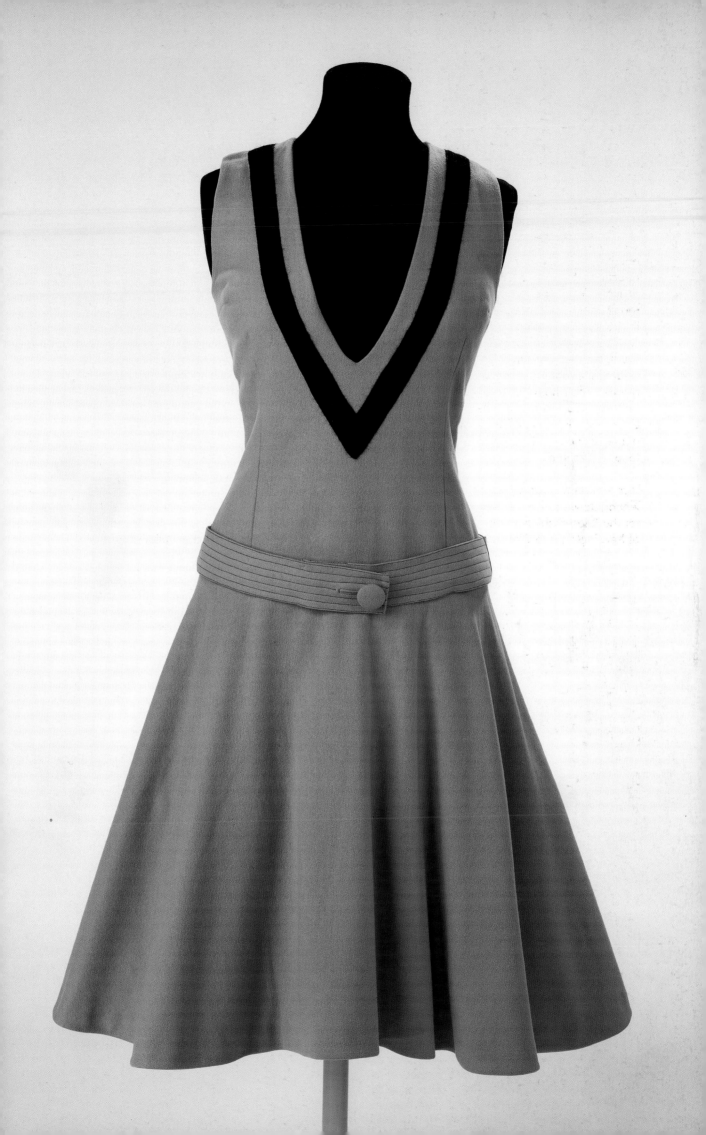

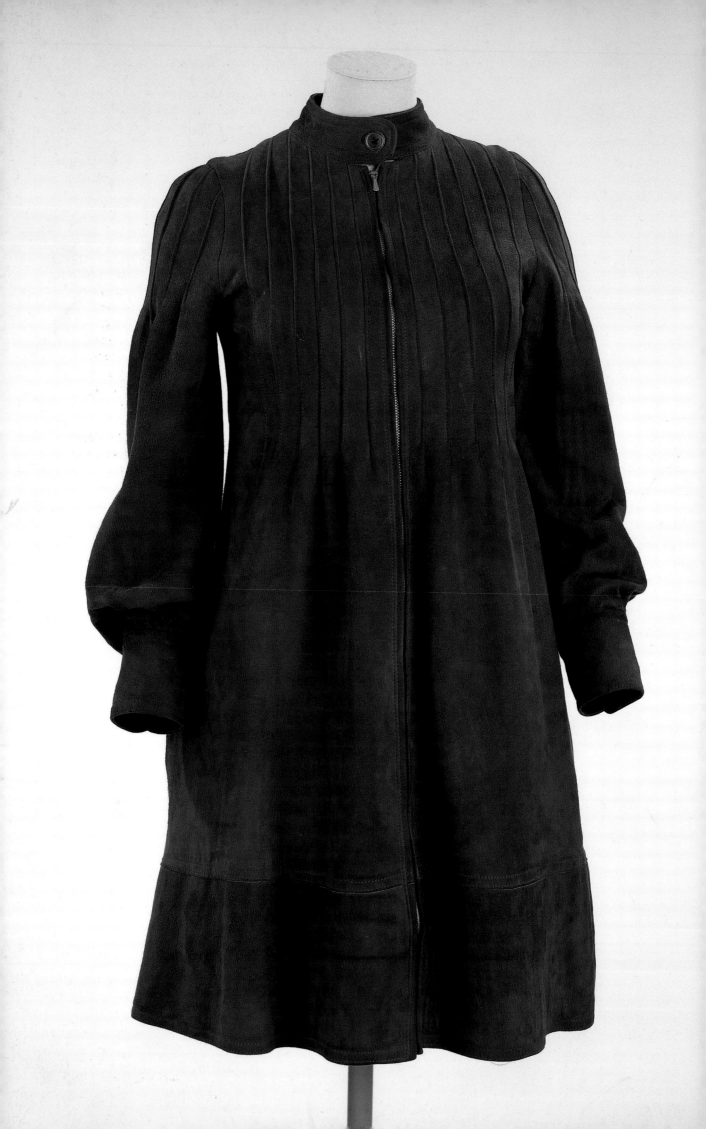

including pin-striped suitings and grey flannel, in subversive ways, and some of her simple dropped-waist dresses anticipated the 'sack' launched in the Paris collections. These early dresses were instant successes and appealed to high-society types and working women. The dramatic V neck of her 1961 pinafore dress is accentuated with applied black braid, reminiscent of a 1930s swimming costume; it was accessorized with the dark stockings, polo necks and simple black shoes typically worn by art-school students and beatniks. Throughout her career, Quant continued to play with conventions, reworking children's clothes, men's underwear and sportswear into witty designs.

Bazaar was a springboard for many other influential designers, including Caroline Charles and Kiki Byrne, who left to set up her own boutique on the King's Road, Glass and Black. Bazaar also showcased the work of leading young designers, among them Jean Muir. Muir enjoyed great success as the designer for the label Jane and Jane, and began manufacturing under her own name in 1966. Her purple suede mini of that year exemplifies her individual sense of the mood of the moment; she continued to work with rich supple fabrics, especially jersey, crepe and leather, in dark, subtle colours, and, steering clear of the continuing shift towards nostalgia and romance, she became known for her austere, graceful classics throughout her distinguished career.

A crucial influence on the development of London designers was the diploma course in fashion design at the Royal College of Art. This was set up in order to supply the post-war clothing industry with trained designers, and government grants enabled students from all backgrounds to continue their education. Designers including Peter Shepherd, Gina Fratini and Gerald McCann graduated from the Royal College in the 1950s. Janey Ironside headed the course from 1956. She assembled an impressive list of external tutors, including the highly influential Liberty print designer Bernard Neville, and developed close partnerships with manufacturing firms to give students a range of experiences in industry.[11] After the new generation of designers had proved that there was a huge international market for British design, it became essential for wholesale fashion houses to hire art-school graduates to update their image.

Opposite Jean Muir, dress. Suede. British, 1965–6. Given by Mrs J. Carter. V&A: T.250–1978.

After graduating from the RCA Gerald McCann worked for the London couturier Harry B. Popper. In 1963 he established a wholesale business that became a major supplier to the 21 Shop at Woollands department store in Knightsbridge, and exported a large quantity of designs to the US. McCann's tailored coats and suits were popular with fashion editors and customers alike. The chocolate-brown wool skirt suit combined wearability and up-to-the-minute styling without being outlandish, with its 'bassett hound' collar, chunky ring-pull zip and very short pleated skirt.

Marion Foale and Sally Tuffin were part of a talented group of students (which included Sylvia Ayton and James Wedge) taking their first degree at Walthamstow School of Art. The two friends were empowered by their RCA training, and particularly by a lecture on pricing garments given by Mary Quant and Alexander Plunket Greene. Instead of taking the normal route and finding employment with a manufacturer, they decided to set up on their own in 1961. Foale and Tuffin were amongst the first to experiment with cutting trousers for women, reducing the numbers of pleats and darts so that

they became flattering, sexy garments.[12] Slim trouser suits with loose tunic tops became popular in Liberty printed silks. Practical and stylish alternatives were provided by Foale and Tuffin in tough cowboy style corduroy and streamlined linen.

Other designers breaking through in the early 1960s included John Bates, who initially found it difficult to get his collections accepted by influential department-store buyers because he had not been one of the well-known group trained at the RCA. Bates had been part of Mary Quant's early adventures in retailing, collaborating with her to create Bazaar's window displays. After an apprenticeship with the London couture house Gerard Pipard, Bates set up his label Jean Varon in 1960. His bikini dress with revealing mesh panel, which won Dress of the Year in 1965, has been seen as a key stage in the evolution of raised hemlines. John Bates was at the forefront of the new experimentation with revolutionary materials such as PVC, and he gained widespread recognition as *the* Mod designer through his creation of Diana Rigg's costumes for the TV series *The Avengers*. These were characterized by a sophisticated interpretation of the

Left Gerald McCann, jacket and skirt. Wool barathea. British, 1968. Worn and given by Miss Marion Giordan. V&A: T.25&A–1979.

minimalist space-age look inspired by Paris designers Cardin and Courrèges.[13]

By 1966, when the Swinging London media frenzy was at its height, an ever-increasing turnover of new styles available in the shops presented a dazzling array of identities. A *Vogue* feature entitled 'Six characters in search of 66' set out the options, ranging from the Modern Medieval Waif, to Sally Bowles (1966 glitter version), Russian Heroine, Ton-up Girl (in a black leather biker suit), the girl from The East Goes West, and Moon Girl in elasticized silver lamé.[14] But the softer, retrospective styles were becoming the dominant aesthetic. Academic Sheila Rowbotham, writing about working in London in her 20s, recalled how she 'revelled in the fast-moving fashion of boutiques like Biba or Bazaar. The sharp zigzags of Op Art were being quickly superseded by the flowing lines inspired by Aubrey Beardsley and the vampish boas of the early silent movies. Young designers dived into the past like raiders searching for lost wrecks of spoil and their time-travelling motifs overlaid the early-sixties quest for an obscured bedrock of truth.'[15]

The prices charged by many boutiques put the clothes made by London's swinging designers well beyond the pocket of the average shopper. A Mary Quant Ginger Group jersey dress cost 8½ guineas in 1967, which was about a week's wages for a young shop assistant at the time.[16] In 1964 Barbara Hulanicki and her husband John Fitz Simon discovered a huge demand for contemporary design at rock-bottom prices. They opened the first Biba boutique in Abingdon Road, Kensington, deliberately distancing themselves from both King's Road and Carnaby Street. Biba's customers included impoverished students as well as pop stars and wealthy bohemian aristocrats; dresses might cost just £3 each (but were so cheaply made that the seams sometimes needed restitching once they had been worn a couple of times). Early best-sellers were simple printed cotton smocks with contrasting collars and cuffs, skinny T-shirts with uncomfortably tight sleeves, and canvas knee-high boots. From the start Hulanicki looked to the past for inspiration when designing for her customers, making short shift dresses out of simple Victorian-style printed cottons. The Biba suit of 1970 combines a traditional textile with a resolutely contemporary silhouette;

Right Jean Shrimpton. 'Schéhérazade '65', *Vogue*, January 1965. 'Skimp dress, bikini top and short short skirt netted together in navy. Terracotta and orange on navy cotton by Wallach. By John Bates for Jean Varon, 6 gns., Woollands.' Duffy/ *Vogue* © The Condé Nast Publications Ltd.

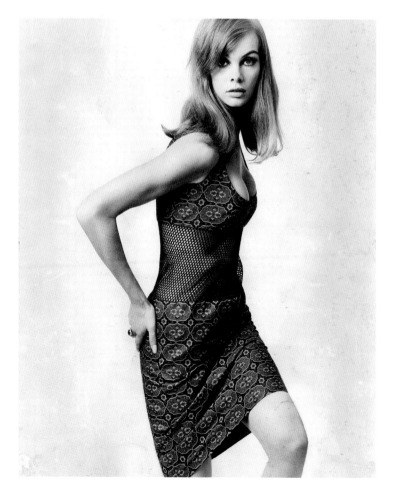

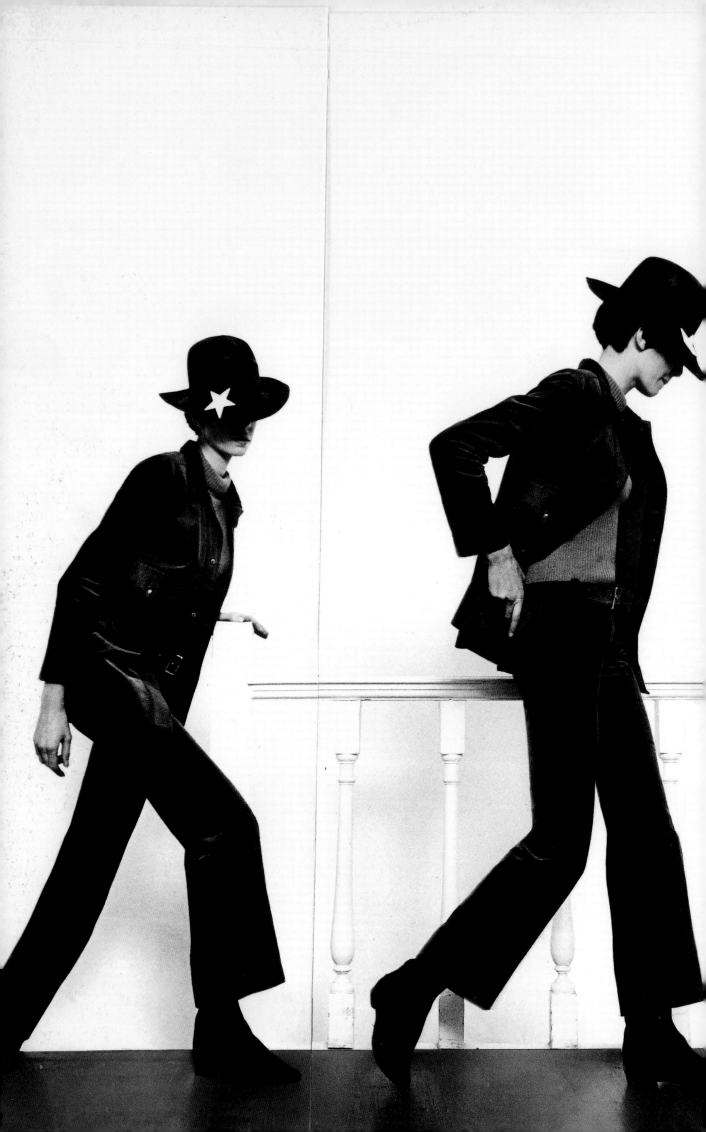

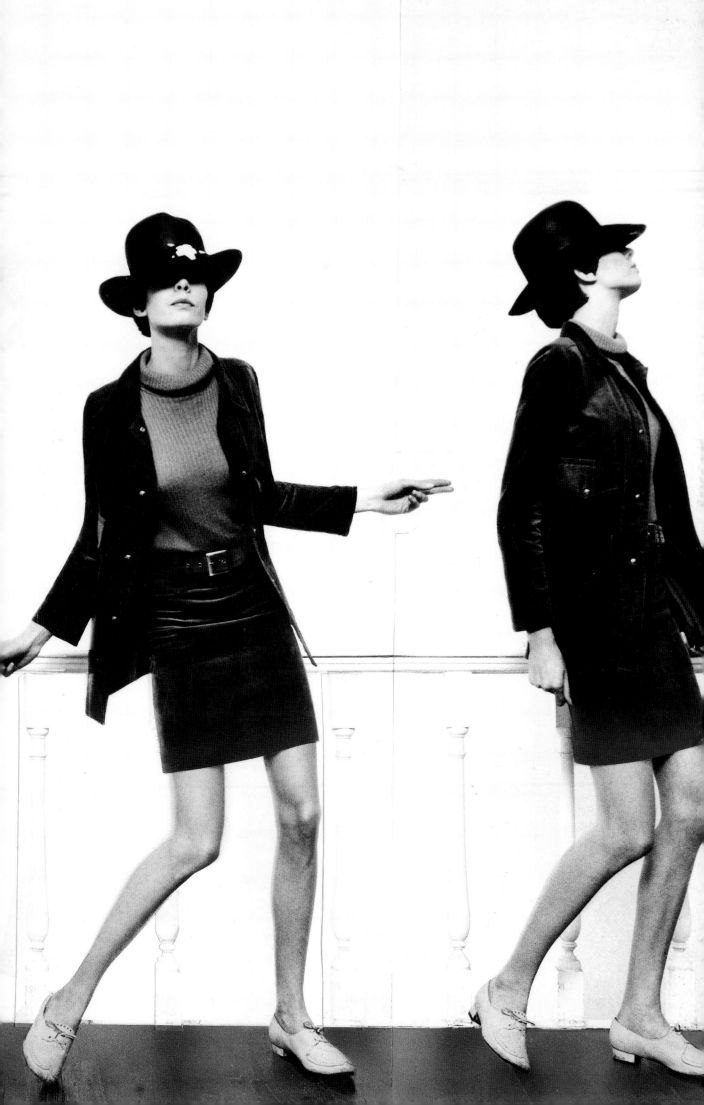

a florid print of cabbage roses, reminiscent of furnishing fabrics, is used for a sharply tailored jacket paired with flared trousers.

Hulanicki's designs tapped into women's desires for romantic, decadent clothes, stimulated by the growing craze for vintage dresses. Her exotic taste had been formed by her childhood in Palestine, under the strong influence of her formidable Aunt Sophie, who dressed in haute couture. Biba cast a spell on the thousands of shoppers who passed through the doors. On a Saturday afternoon the changing rooms overflowed onto the streets, with women trying on 'the slithery gowns in glowing satins, hats with black veils, shoes stacked for sirens'.[17]

Ossie Clark was another major force behind the rejection of short, structured clothes in favour of the return to a more sensual form of femininity. He showed early promise while studying at the Royal College of Art and with the backing of Alice Pollock, the influential designer and proprietor of Quorum, he became the favoured designer of many celebrities including Bianca Jagger. Clark excelled at cutting dresses from chiffon,

crepe and satin, and using his wife Celia Birtwell's fabric designs, created a uniquely sexy and glamorous look for the late 1960s. His long, structured coats inspired by late eighteenth-century redingotes were equally delectable. The cotton velvet coat of 1970 is a striking example of the use of a strong Birtwell floral print combined with a flattering tailored cut.[18]

Some of the most striking signs of the conflict between looking to the future and a new mood of nostalgia were seen in men's wear. Pierre Cardin was for many the ultimate designer for men, rather than any of the London designers. He was a true progressive, designing for the 'modern international man who travels and wants functional, lightweight and elegant clothes'.[19] His 'Cosmos' collection of 1966/7 was too extreme to enter the mainstream, but elements of the look such as turtle-neck sweaters, and zipped tunics in bonded jersey, were taken up and worn with more accessible styles. A range of alternative role models for the fashionable male emerged, from Regency dandies to San Francisco hippies. However, thanks to a few enlightened individuals working in the Savile Row tradition, London retained

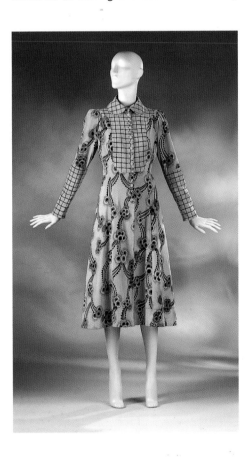

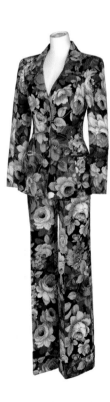

Previous pages
'Young Idea strides ahead', *Vogue*, March 1966, pp.130–1. Corduroy suit, by Foale & Tuffin, hat by James Wedge. Ronald Traeger/ *Vogue* © The Condé Nast Publications Ltd.

Far left Ossie Clark and Celia Birtwell, coat. Printed cotton velvet. British, 1970. Given by Rose Jones. V&A: T.98–2001.

Left Barbara Hulanicki (Biba), suit. Printed cotton. British, 1970. Given by Miss Petra Siniaswski. V&A: T.265-A–1984.

Opposite Pierre Cardin, 'Cosmos' outfit. Wool jersey. French, 1967. Given by M. Pierre Cardin (Cecil Beaton Collection). V&A: 703-c–1974.

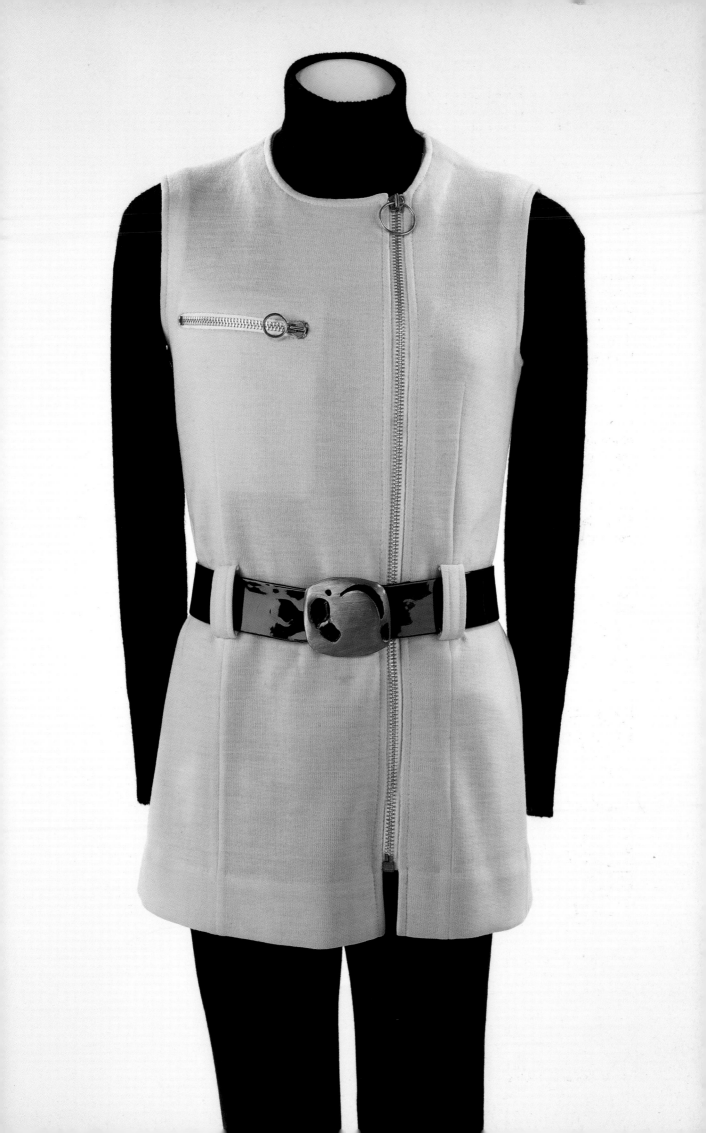

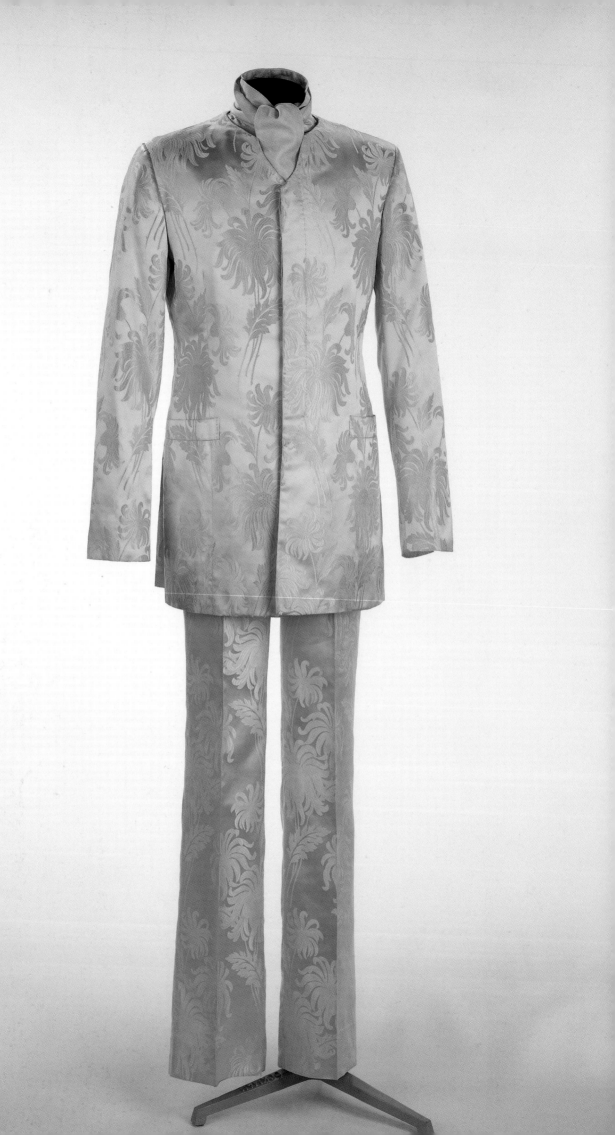

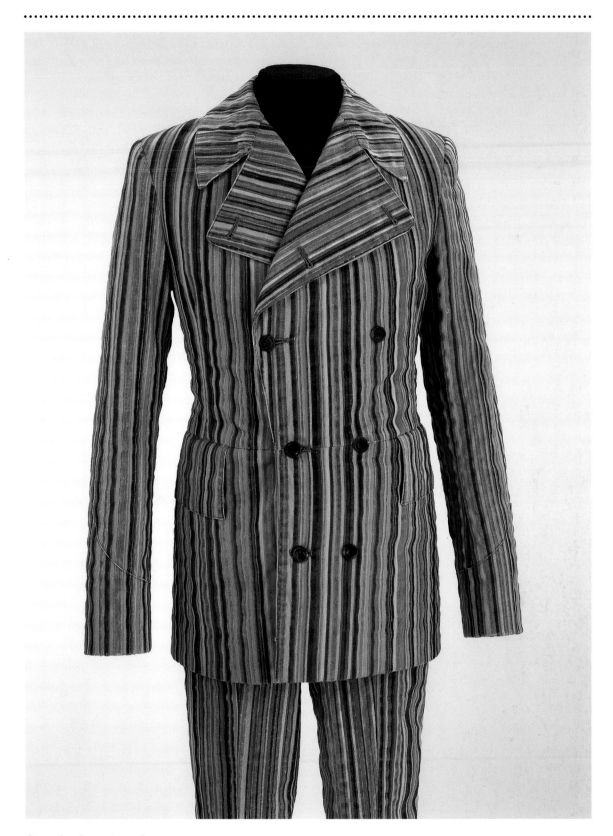

Opposite Rupert Lycett Green
(Blades), suit. Silk. British, 1968.
Worn and given by Mr Rupert
Lycett Green. V&A: T.702-
c–1974.

Above Mr Fish, suit. Printed
corduroy. British (American
textile), 1968. Worn and given by
Mr David Mlinaric. V&A: T.310-
A–1979.

its position as the centre of elegant masculine fashions.

The first company to break through the 'stuffed shirt barrier in good tailoring'[20] was Blades, which was opened in 1963 by gentlemen-amateurs Rupert Lycett Green and Charley Hornby. With the help of their expert cutters, the company attracted a diverse range of customers, including the Beatles. Lycett Green's own unconventional yet subtle style is illustrated by the Blades suit of 1968, with its slim cut and neat Nehru collar, made in a lustrous cream silk woven with a design of chrysanthemums. From 1962 Turnbull and Asser, of Jermyn Street, became known for their flamboyantly patterned shirts and ties created by Michael Fish. He opened his own Mr Fish boutique in 1966 in Mayfair, and provided his well-heeled customers with a distinctive reconciliation of bohemian flair with close attention to quality and detail. The double-breasted suit was custom-made for interior designer David Mlinaric out of a printed corduroy furnishing fabric purchased in the US.

Experimentation with cut and fabric was not only taking place in classic men's wear tailoring. The flowing kaftan-like gown from Thea Porter's exclusive Soho boutique illustrates the complete transition in women's wear from the Paris-inspired, highly structured couture gowns of 10 years earlier. The late 1960s dress is a fusion of influences from history and Eastern cultures – its raised waist evokes the early nineteenth-century empire line, but it is cut from a selection of exotic textiles.

The work of Mary Quant and her successors made a fundamental contribution to the enduring image of London as an international centre of creativity in music, art and fashion. Building on the long-standing traditions of the London rag trade, the 1960s entrepreneurs have had a lasting impact on contemporary design. Their highly original approach to the technical and promotional aspects of fashion, their ability to react quickly and without condescension to youthful consumer trends, and the invaluable training they received from London's art schools, have all left their mark. Following a lull in the 1970s, London is once again regarded internationally as the leading source of innovative and adventurous fashion – and for many of the same reasons that secured its reputation during those heady days of the Swinging Sixties.

Left Caroline Smith, illustration for *Queen*, June 1965.

Opposite Thea Porter, dress. Silk chiffon and brocade. British, c.1970. V&A: T.900–2000.

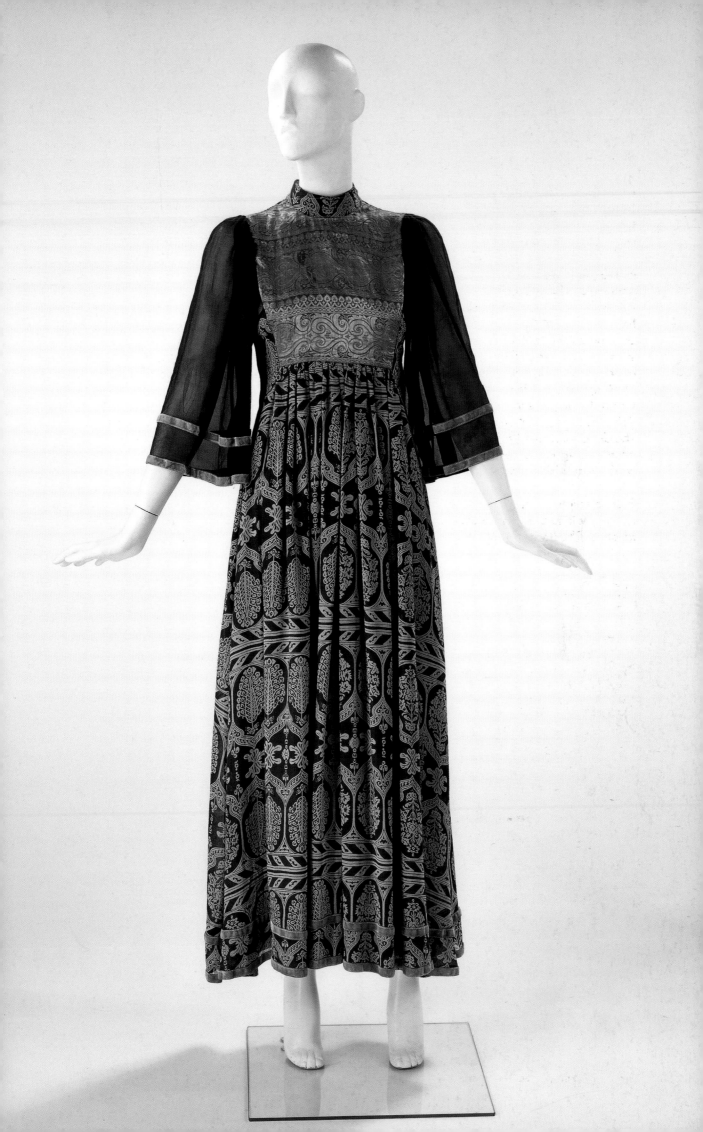

Mary Quant

Mary Quant's first creations followed London's couture traditions, and her first job after leaving college was with the Mayfair milliner Erik. But even in the early years, her garments were 'frankly audacious – and worn by the audacious'. She was credited with many revolutionary developments, which included the miniskirt, tights dyed in bright, solid colours, and the use of plastics and PVC (polyvinyl chloride). Her first designs using PVC were beset by production difficulties, and it took two years' experimentation with manufacturing processes to bond the seams of garments successfully. The eventual result was the 'Wet Collection' of 1963.

Mary Quant designed and presented a complete corporate identity, made instantly recognizable through the use of the daisy logo. This was circulated alongside countless reproductions of the designer's own image, with her distinctive Vidal Sassoon hairstyle.

The mass market appeal and commercial potential of Quant's designs was recognized by the American chain store J.C. Penney in 1962, when she secured a lucrative deal to design ranges for their vast empire of shops across the USA. A year later her clothes became available to a wider public around Britain when she set up her diffusion label Ginger Group, which was available at in-store boutiques at 160 department stores. In a further development of branding Quant designed minimal underwear, with her 'Youthlines' range, using new modern fibres such as Lycra to accompany her unstructured, informal clothes. 'Youthlines' was produced from 1965 and this was followed by a Mary Quant brand of make-up in new, bright colours presented in paint boxes.

Quant's products were intended to be worn by the emancipated woman: 'I want free-flowing, feminine lines that compliment a woman's shape, with no attempt at distortion. I want relaxed clothes, suited to the actions of normal life.' Quant received many awards acknowledging her contribution to the British fashion industry, including an OBE. In 1973 her achievements were marked by a retrospective exhibition at the London Museum. The energy and bravery of her company's approach to business was a catalyst for change and spearheaded the invasion of the international market by London fashion designers. The fashion journalist Ernestine Carter equated her work with that of Chanel, Quant's personal heroine: 'It is given to a fortunate few to be born at the right time, in the right place, with the right talents. In recent fashion there are three: Chanel, Dior, and Mary Quant.'

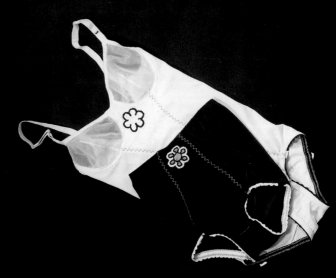

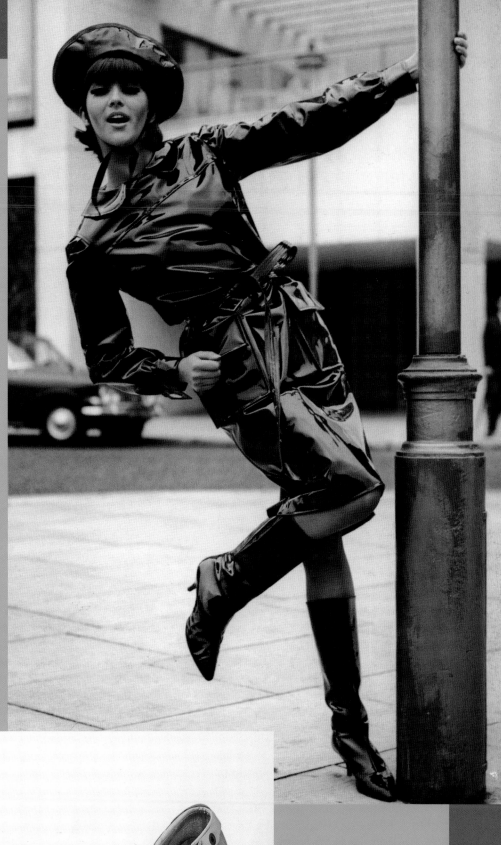

Opposite left Mary Quant, design. Pencil and fibre tip on paper. British, 1967. V&A: E.520–1975.

Opposite right Mary Quant, bodystocking and pantie girdle, synthetic jersey and nylon. British, late 1960s. Given by Mrs M. Wilson MacDonald. V&A: T.442–1988 and T.443–1988.

Below Mary Quant, ankle boots. Injection moulded plastic, lined with cotton jersey. British, c.1965. Given by Susannah Lob. V&A: T.59-2–1992.

Right Model Jackie Bowyer in 'Christopher Robin' raincoat by Mary Quant, October 1963. © Getty Images.

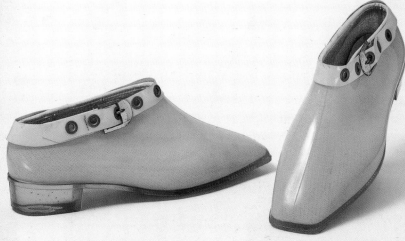

Brave New London

ARCHITECTURE FOR A SWINGING CITY
BRONWEN EDWARDS

In 1962 the *Sunday Times Magazine* proclaimed that 'London's new buildings are constantly in the news.'[1] The arrival of monumental concrete and glass towers on the scene was sometimes bitterly contested, but more often was hailed as a fitting symbol of a 'Brave New London'. This architectural landscape provided a familiar backdrop for 'Swinging London' films and fashion photographs. But these buildings also suggested a harder-edged, more permanent version of the new city than the Swinging London of painted-ply shop fronts, quickly stitched minidresses and heady, drug-fuelled nights. The new buildings were so newsworthy precisely because of the many broader issues at stake: how should commercial consumption, civic grandeur and an efficient transport system in Central London be combined? And how far should London's history be integrated into its present and future? This was a moment when London's future identity – in sartorial, architectural and social terms – appeared to hang in the balance.

The city had emerged from the devastating effects of World War II, and the crippling austerity of the early post-war years, when it was coloured 'the greyness of twilight'.[2] This greyness was to be found in the city's dirty, drab walls, in the rubble of bombsites, and even in the fabrics of fashionable metropolitan dress, all captured in the restrained hues of the photographs in architectural and fashion magazines. Now, at last, came a period of renewed ambition. Visions for London not only speculated about the nebulous 'character' of the city, but also on its future physical form: its buildings and street patterns. The schemes varied enormously in scope: some merely proposed the construction of individual buildings; others involved razing whole swathes of Central London to the ground and beginning again. These urban visions chimed with the broader cultures of Swinging London, providing a suitably modern setting for its new citizens. Crucially, they reordered the city, shifting its geographical, cultural and generational focus in line with the new spirit of the times. The *Guardian* identified 'a new London… built for those who were not yet born at the time of the blitz. A London where Carnaby Street takes precedence over Downing Street, where pin stripe and bowlers give way to bell bottoms

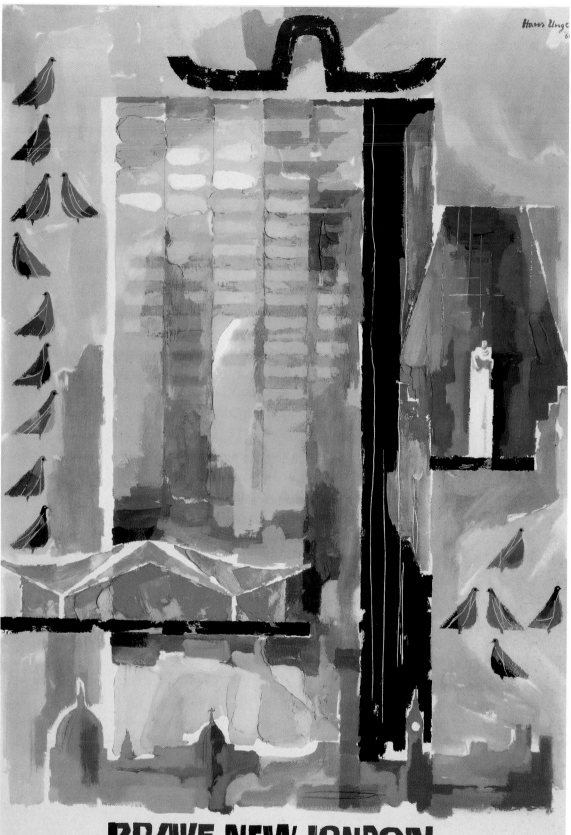

BRAVE NEW LONDON

Look up at the bold and uncompromising buildings of today. At no time since 1666 has London had such a fresh and sudden skyline.

A London Transport leaflet *Brave New London* identifies some of the more notable new buildings, and shows how to get there. Free from the Travel Enquiry Offices at Piccadilly Circus and St. James's Park Underground stations, the City Information Centre, St. Paul's Churchyard, or from the Public Relations Officer, London Transport, 55 Broadway, Westminster, S.W.1.

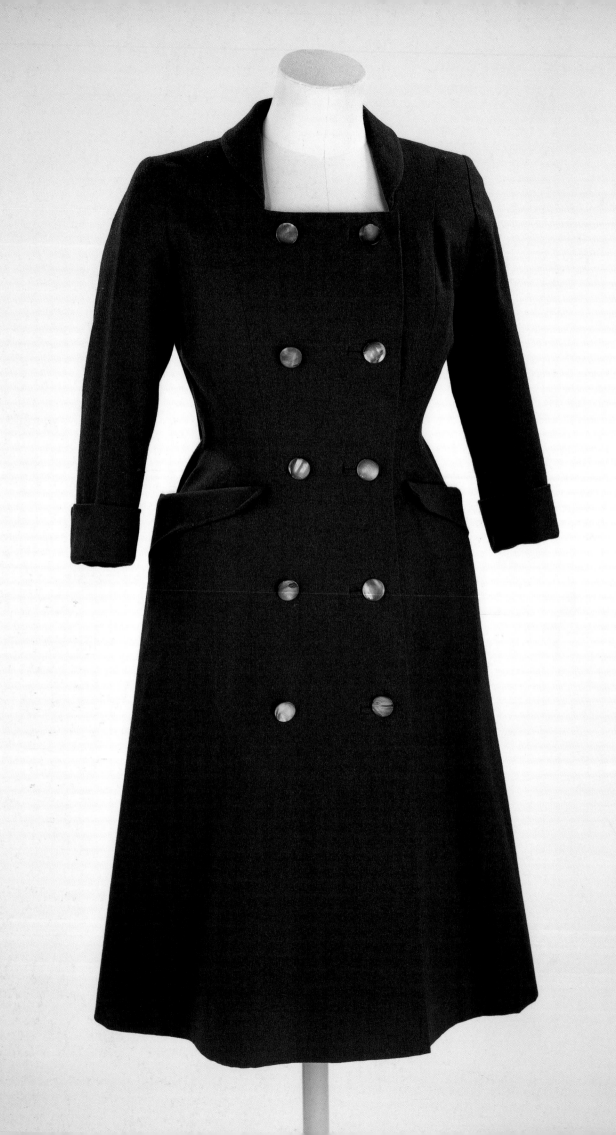

and polyvinyl chloride.'[3] But the plans also moved beyond the dominant myth of Swinging London, pointing to a range of alternative visions, in which the emblematic fashionable consumption of Carnaby Street or the King's Road was variously celebrated, contested or concealed. The relationship between designer dress and modernist tower was more complicated than it might first appear.

One challenge was that the sites for re-development frequently abutted or overlapped with pre-existing sites of fashionable consumption. By the 1960s, the heart of the West End was a well-established national and international shopping hub, still vibrant and successful, managing to withstand the increasing competition from provincial and suburban centres. The area had been built up gradually over centuries. Its principal arteries were Oxford Street, Regent Street and Piccadilly, with smaller streets such as Bond Street and Savile Row weaving behind and in between them. While retailers and consumers were relatively content with the status quo, developers were preparing to transform the scale of the West End's buildings, and state planners were scheming to replace the historic street pattern with a modern, planned metropolis.

Office blocks sprang up all over the West End, most famously Centre Point at the junction of Tottenham Court Road and Oxford Street. Westminster City Council, national government and big landowners such as the Crown Estate spent the 1960s producing even more radical schemes for key sites, notably Piccadilly Circus, Oxford Street, Regent Street and Covent Garden. These plans foundered or, in the case of Covent Garden, were dramatically modified, for a number of reasons: lack of money, community opposition, political infighting, and eventually, the fiscal crisis of the early 1970s. This coincided with a change in broader public attitudes towards historic townscapes associated with the rise of the architectural conservation movement. However, in the 1960s, it was genuinely believed that Central London might be re-drawn as a rational, planned urban landscape, complete with grid-plan, pedestrian plazas and monolithic tower blocks. The West End had been subject to changes before: the building and rebuilding of Regent Street,

Opposite Digby Morton, dress. Wool. British, c.1955. Given by Miss Agnes Kinnersley. V&A: T.340–1980.

Right 'Oxford Street Motorway', from Ministry of Transport, *Traffic in Towns* (HMSO, 1963), p.143.

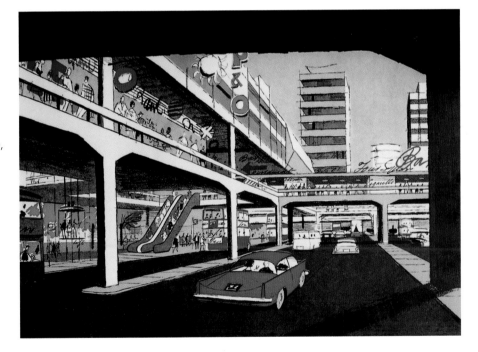

for example.[4] However, these proposals were potentially on a much more dramatic scale.

Planner Colin Buchanan's *Traffic in Towns* report of 1963 proposed the vertical segregation of traffic in the West End. Under the plans 'the West End would be mainly a shopping and entertainment area, and a two-level structure with pedestrians on the first floor and buses and other vehicles on roads beneath them would be built over the whole area.'[5] Oxford Street was to be replaced by an urban motorway, giving the car clear priority over the shopper. Similar ideas informed a series of proposals for Piccadilly Circus between the late 1950s and early 1970s. These culminated in Westminster Council's proposal of 1971, *An Aid to Pedestrian Movement*. Here the West End was to be criss-crossed by an elevated transit system of yellow pods. The curve of Regent Street was preserved, but the street was to become a pedestrianized, covered mall, built on a deck above the road, and flanked by brutalist, concrete structures containing shops and offices. None of these plans seemed to take much account of the new shopping cultures thriving in Carnaby Street,

only yards away. Rather, they attempted to replace the tangle of congested streets that gave the area its character, disrupting the crucially important relationship between road, pavement and shop window on which West End shopping had long depended.

Those planning the rebuilding of the West End had other priorities in mind. This was particularly noticeable in their schemes for Piccadilly Circus, which became the focus for one of the most notorious planning battles of the post-war years. The Circus had long been central to the iconography of London, recognizable the world over. Yet the fundamental reason for the controversy was not a desire to protect the physical fabric of this much-loved landmark, but rather that developers, landowners, architects, planners and the various campaign groups had deeply conflicting visions for its future. It was at once a centre of shopping, a hub of nation and Empire, a key metropolitan traffic node, and a nucleus of London's post-war office boom. Official plans sought to strip the commercial glitz from Piccadilly Circus, redesigning it as a more 'chaste' and civic space, a new kind of forum for a modern nation.

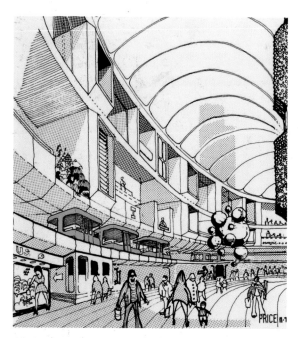

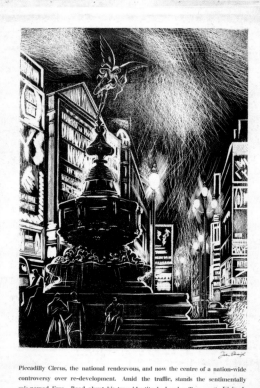

Above Working Party on the Introduction of a New Mode of Transport in Central London, 'Regent Street', *An Aid to Pedestrian Movement* (Westminster City Council, 1971).

Right John Farleigh, *Piccadilly Circus*, poster for the London Underground. 1960. V&A: E.681–1987.

Piccadilly Circus, the national rendezvous, and now the centre of a nation-wide controversy over re-development. Amid the traffic, stands the sentimentally mis-named Eros. Read about his true identity in London Transport's *Visitor's London*, price 5/- at the Travel Enquiry Office, in the Underground Ticket Hall almost directly beneath him, at St. James's Park Station, or at the City Information Centre, near St. Paul's Cathedral.

Underground or any bus to Piccadilly Circus

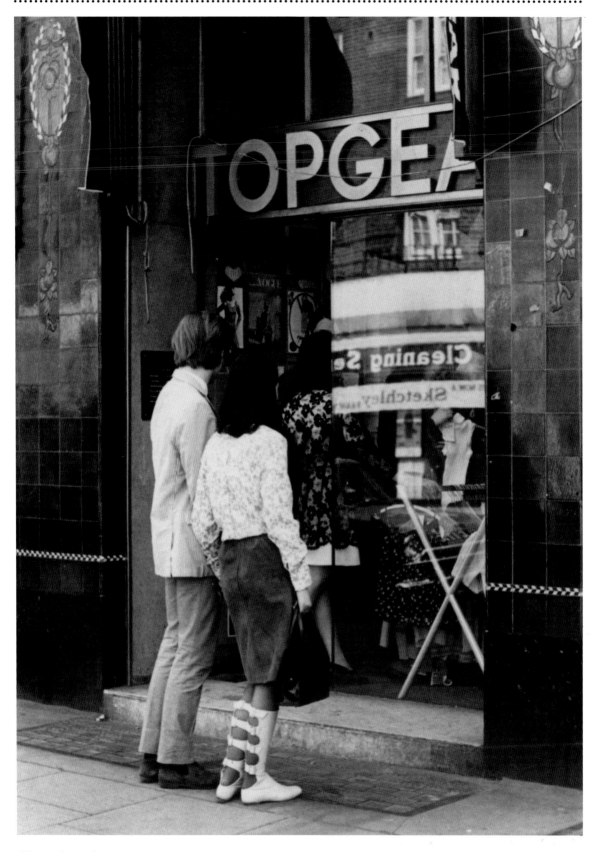

Above 'A Couple
Window Shopping in
King's Road, Chelsea.'
1966. © Getty Images.

The other key impetus for changing London came from the property developer. The West End was a centre of post-war office construction, occasioned by the effects of bomb damage and over a decade of neglect. While few of the local authority planning ideas were realized, office blocks transformed the cityscape. The *Sunday Times Magazine* commented, 'Towers, domes and spires, once the focal points of the skyline, now peer through the sheer glass walls of office buildings designed for light, air, efficiency and profit.'[6] The architect Richard Seifert's speculatively built Centre Point of 1964 towered over Oxford Street, symbolizing this new force in the city. The property developers were a different kind of entrepreneur from the likes of John Stephen and Mary Quant. Their interest lay in the huge incomes generated by prominently sited office towers, rather than in the fashionable consumption taking place on the ground floors of the West End's buildings. Of even less concern were the precarious and meagre turnovers of the small boutique sites in minor streets.

Many of the tall commercial buildings of the 1960s are now viewed as ugly, and the development plans have come to be seen as wrong-headed or naïve; yet both betrayed a genuine belief in the desirability of the 'newness' of urban fabric, which echoed the incessant Swinging London refrain of 'new, mod, modern'. Architectural commentator Edward Carter expressed a common sentiment in *The Future of London*: 'All over the world people are trying to live twentieth-century lives in ancient cities almost totally unsuitable for present needs; and yet these cities, scruffy, squalid, congested, badly equipped, and in many parts so ugly, are the focal centres of civilization.'[7] In a London Underground poster of 1960 (see p.43), visitors were drawn to a 'Brave New London': 'Look up at the bold and uncompromising buildings of today. At no time since 1666 has London had such a fresh and sudden skyline.' These buildings provided an architectural aesthetic of unequivocal modernity, matching the clean lines of 1960s clothes such as Quant's 'Peachy' dress of 1960. The 'shock' produced by the new designs – the scandalously short skirts, the glaring colours, the prominent zips that invited unzipping – was similar to the reaction provoked by 'brutalist' concrete architecture.

Opposite Mary Quant, pinafore dress, 'Peachy.' Wool. British, 1960. Worn and given by Mrs Margaret Stewart. V&A: T.27–1997.

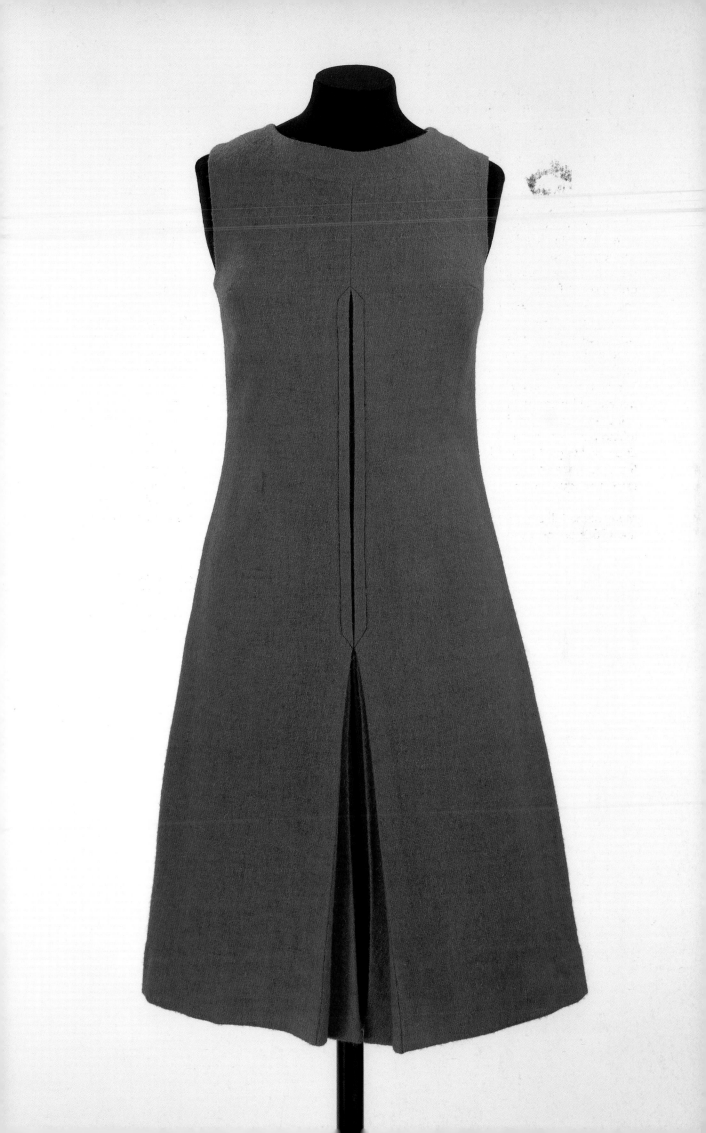

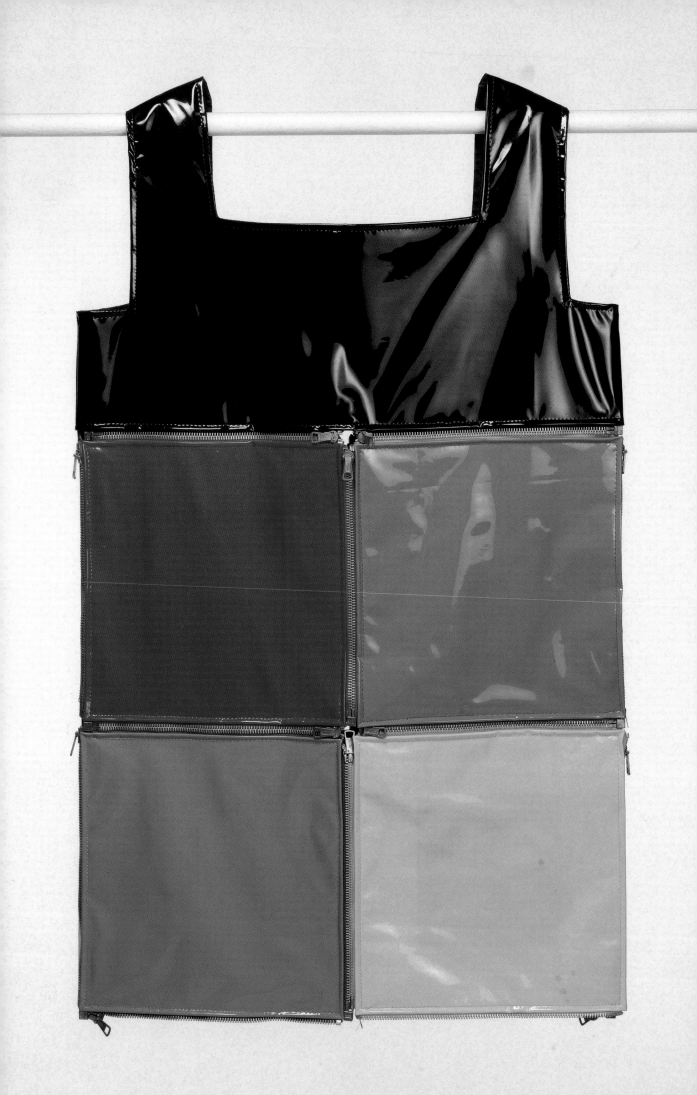

The designers of architecture and clothes also shared a preoccupation with new materials, or at least in the 'appearance' of newness: concrete and plastics, nylon and PVC. PVC-clad women were conspicuous in the mythologizing of Swinging London from *Time* to *The Neophiliacs*. Quant, one of the first to pioneer the use of the material with her 'Wet Collection', described herself as being 'bewitched' by 'this super shiny man-made stuff and its shrieking colours, its vivid cobalt, scarlet and yellow, its gleaming liquorice black, white and ginger'.[8] The fabric soon became symbolic of Swinging London, its very shininess mirroring the expanses of glass in the new architecture and the shop windows.

The newness of Swinging London was also articulated through the speed of modern urban life and its need for constant renewal. The swift fashion changes matched the shifting shape of the West End. This theme was picked up in *Time*: 'Even the physical city seems to shift and change under the impetus of the new activity. Throughout London, wreckers and city planners are at work. Once a horizontal city with a skyline dominated by Mary Poppins' chimney pots, London is now shot through with skyscrapers...'[9] The willingness of architects, planners and developers to raze the city to the ground and start again betrayed a new concept of the fleeting city, at odds with the value placed on its historical fabric and character. This kind of planning was highly significant, representing 'a deliberate act of erasure, an act of forgetting, not so dissimilar in spirit to the mood and ambience of the "Swinging Sixties" elsewhere in London.'[10] It fitted with the succession of boutique shop fronts in the King's Road and Carnaby Street, which dazzled for short periods before being replaced with something newer, shinier, brighter. It also resonated with the new-wave ideas of architectural groups such as Archigram, who emphasized the ephemerality and flexibility of the urban landscape – in a sense, its consumability.

Archigram architect Peter Cook believed disposability was highly appropriate for contemporary architecture, explaining: 'my wife wears clothes which will be an embarrassment in two years. Hospitals have paper sheets. Soon it won't be so shocking to throw away a building we have been using.'[11] Contemporary furniture designers were experimenting with inflatable and paper furniture.[12] Nothing, it seemed, need last for long. The Archigram group had a mantra

Opposite Stephen Willats, PVC dress. British, 1965. V&A: T.19–1991.

Right Archigram exhibition panel featuring Ron Heron's *Instant City* designs. 1969. V&A: Circ.472–1972.

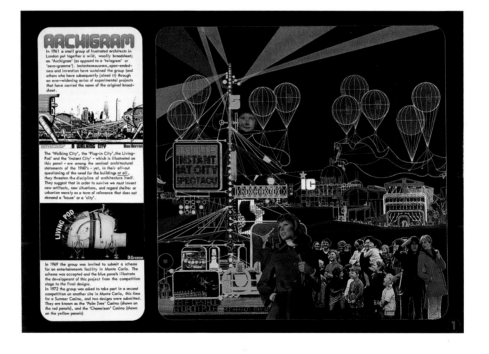

of 'instantaneousness, open-mindedness and invention'.[13] Their projects included the 'Plug-In City' of 1964, which would 'continually build and rebuild itself, tear itself down, change its direction or go off in little spurs'.[14] There was also the itinerant sci-fi 'Walking City' of 1964, followed by the inflatable 'Blow-Out City' of 1965. These ideas culminated in Ron Heron's designs of 1969 for an 'Instant City', featuring brightly coloured disposable urban structures which could be parachuted into any landscape, replete with technicolour advertisements and happy consumers.

The world of fashion had always embraced ephemerality, but it was particularly evident in the trends of the 1960s. Brightly coloured, easily laddered nylon tights were sold in great quantities to be worn with the ever-shorter miniskirt. Their association with youth and permissiveness was sealed in a notorious scene in Antonioni's 1966 film *Blow-Up*, in which they were worn and removed by actresses Jane Birkin and Gillian Hills. Other new designs were pushing disposability to its very limits. In the same year, Ossie Clark launched his 'throwaway' paper shift dresses, with prints designed by Celia Birtwell (see p.88). The

buyer for Woollands' 21 Shop was quick to stock them: 'I just can't see how they can go wrong... They look absolutely marvellous on, and for 25s, a girl can wear one half a dozen times instead of paying 12gns for a dress she might wear only the same number of times. The colours are very good, and in singing plain tones they will be just right for the summer.'[15] The *Drapers' Record* also reported on the new 'throw-away' paper dresses by Dispo, on sale from £1 2s 9d at the Jump Ahead boutique in Pimlico Road. New designs were being brought out every month to replace the old, obsolete models.

As the 1960s wore on, the obsession with all things 'new' was gradually supplanted by a more nostalgic trend. The fixation of companies such as Biba with historical designs from late Victorian Art Nouveau to 1930s Hollywood glamour was just one expression of this shift. Planners were also beginning to take more account of London's existing cultures and architectural fabric. As Covent Garden emerged as a site for the planners' schemes, architectural commentator Kenneth Browne set out a rather different agenda for the West End in a series of articles for the *Architectural Review*, in which such terms as 'distinctive

Opposite Dispo, paper dresses. 1967. V&A: T.176–1986 and T.181–1986.

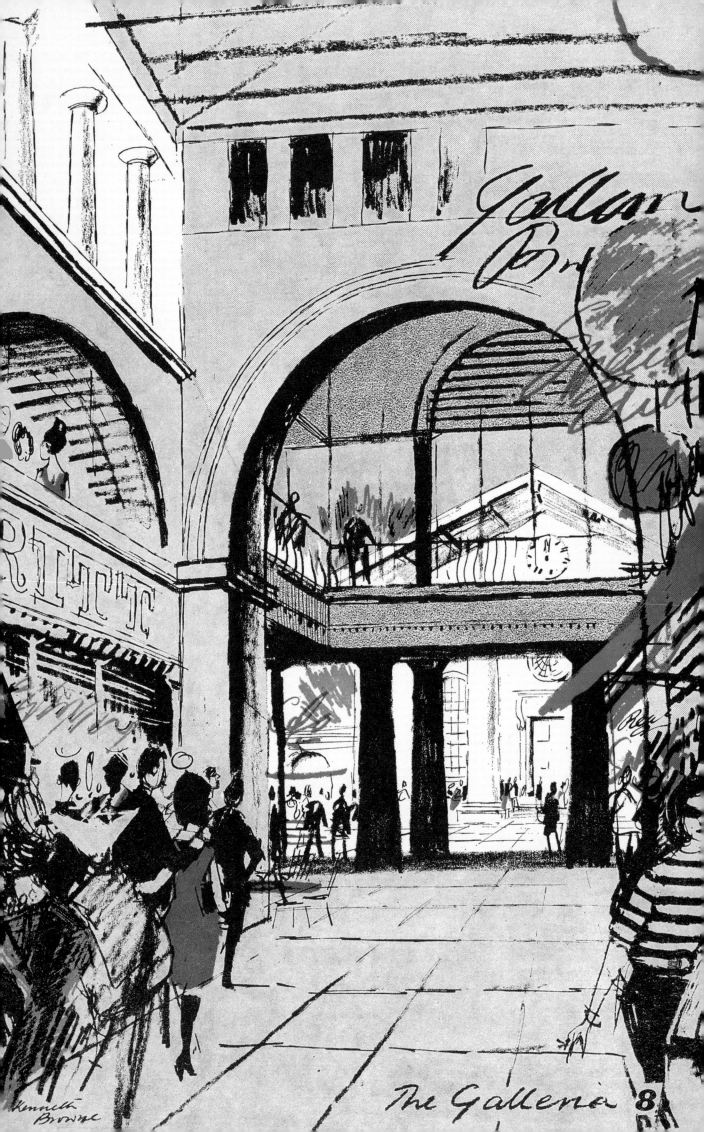

The Galleria 8

character', 'townscape', 'continuity', even 'conservation' set the tone. 'What future has Covent Garden? The prospect is not encouraging. London, "the unique city"… is being straightened out, having its eccentricities corrected, its character impoverished, not only by piecemeal development but also by the doctrine of the clean sweep (politely called comprehensive development).'[16] He advocated recasting Covent Garden as a 'Latin Quarter for London', 'the place where all paths cross… a natural melting pot for people and ideas … a place where anything can happen… This give-and-take has to be reflected in the architecture; free thought cannot blossom in a gridiron.'[17] In his vision for the area, urbane, fashionable consumers were depicted against a backdrop of the historic market, filled with cafés, studios and little shops. Implicit in this new approach was a desire to incorporate London's existing character, including the flourishing consumption cultures of the 1960s into new models. Soon many key buildings in the West End would be listed, signalling a renewed respect for London's

history, and demanding a new approach to planning its future shape.

In the 1960s architects and planners had to find some way of accommodating the aspects of Swinging London that they found most problematic: its essential fluidity, flexibility and resistance to being 'planned'. The pedestrianization of Carnaby Street in the early 1970s, with its brightly coloured plastic flooring, marked its permanent exclusion from the 'Scene', and showed the difficulty of marrying planned development to the spontaneity of youthful consumer culture. After all, the most fashionable events of the decade took place in the tangle of backstreets, and in the hastily redecorated interiors of Victorian shop buildings. The 1960s planners had imagined a Brave New London whose concrete monumentality and grid-like street plans would soon seem to be the dreary, pleasure-devoid territory of old-guard modernists. By the end of the decade a revitalized interest emerged in the possible creative connections between the newest, most fashionable shopping cultures and the historic fabric of the city.

Opposite 'A Latin Quarter for London.' *Architectural Review.* March 1964, p.198.

Right Barbara Hulanicki (Biba), dress. Acrylic jersey. British, c.1969. Given by Karina Garrick. V&A: T.203–1991.

A New London

As he sped along the curving M4 motorway from London Airport below the unfamiliar howl of jet airliners, there would have been soaring new glass and concrete blocks breaking the skyline, the tallest of which, the GPO tower, had only just been opened... Next, perhaps, he would have been struck by the change in appearance of the young... Nothing would have surprised him more than the exhibitionistic violence with which these new fashions grabbed the attention – the contrasts, the jangling colours, the hard glossiness of PVC, the show of thigh...

Christopher Booker's critique of Swinging London, *The Neophiliacs*, cast architecture and fashion as key components of the urban scene. As he tracked a 1950s time traveller encountering the city in 1965, fashions were set alongside monumental modernism as markers of change. This passage echoed the fashion photography of *Vogue* and *Queen*, in which London's new architecture provided a backdrop for the garments of a new generation of designers. Mary Quant drew attention to the connectedness of 1960s fashion and other aspects of contemporary culture, significantly including architecture in her list: 'fashion... reflects what is really in the air. It reflects what people are reading and thinking and listening to, and architecture, painting, attitudes to success and to society.'

Architecture was more than a stage for the performance of Swinging London. Architectural plans and development schemes articulated yearnings to build a 'Brave New London', which would function as a new heart for the metropolis and an emblem of Britishness, bolstering the nation's position in the new world order. Yet this was an enterprise that risked the very character of the city, a historic character which fed into the dynamic consumer cultures of the West End. As Peter Ackroyd has commented: 'It is the eternal aspiration, or perhaps delusion, that somehow the city can be forced to change its nature by getting rid of all the elements by which it had previously thrived.'

Below 'The Height of Fashion', *Vogue*. August 1963, pp.26–7. Silano/ *Vogue* © The Condé Nast Publications Ltd.

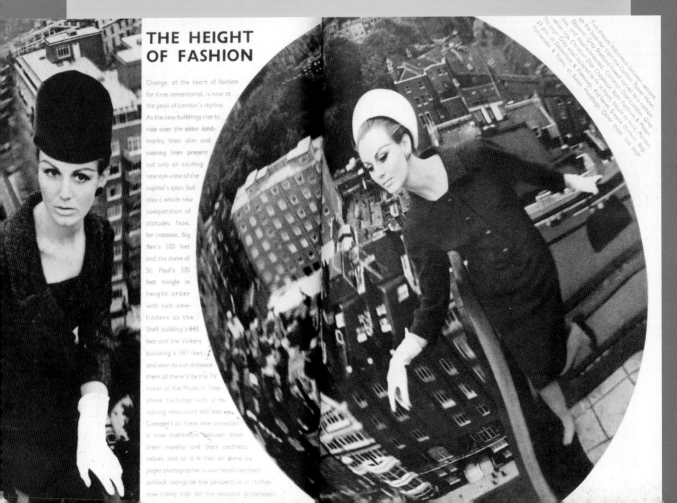

THE HEIGHT OF FASHION

Change, at the heart of fashion for time immemorial, is now at the peak of London's skyline. As the new buildings rise to ride over the older land-marks, their slim and soaring lines present not only an exciting new eye-view of the capital's span, but also a whole new competition of altitudes. Now, for instance, Big Ben's 320 feet and the dome of St. Paul's 370 feet mingle in height order with such view-finders as the Shell building's 343 feet and the Vickers building's 387 feet; and soon to out-distance them all there'll be the TV tower of the Museum Tele-phone Exchange with a re-volving restaurant 603 feet up. Cogent on these new pinnacles is now midstream between their sheer novelty and their aesthetic values, and so it is that on these six pages photographer Silano headlines their outlook alongside the perspective of clothes now riding high for the seasonal go-between.

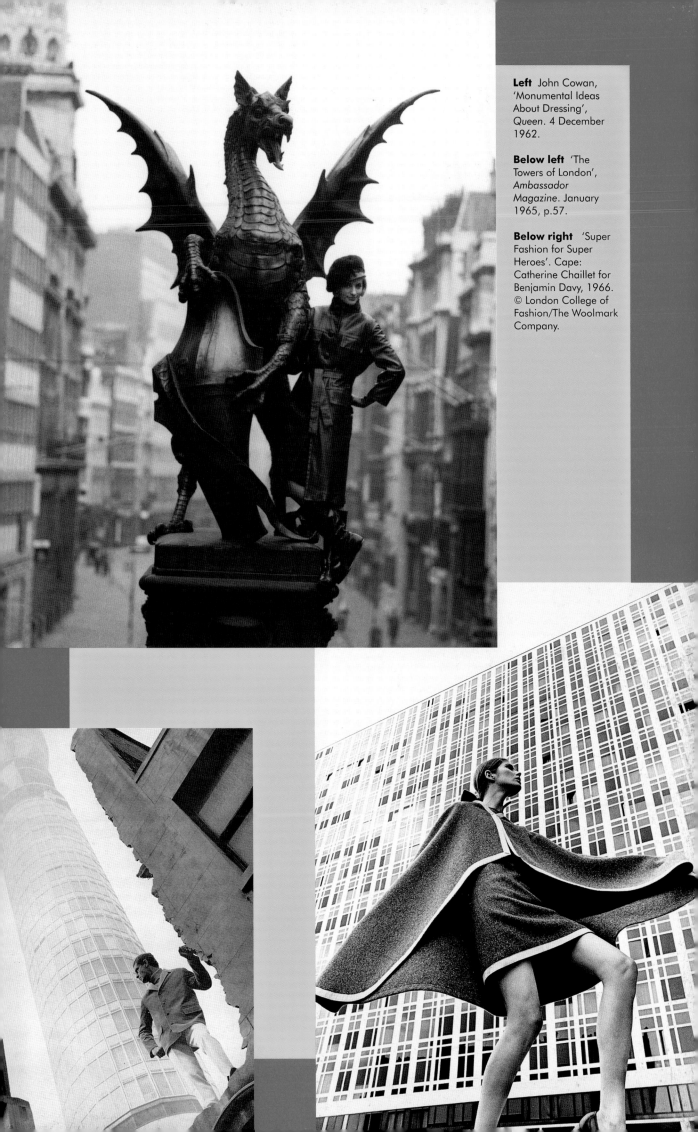

Left John Cowan, 'Monumental Ideas About Dressing', *Queen*. 4 December 1962.

Below left 'The Towers of London', *Ambassador Magazine*. January 1965, p.57.

Below right 'Super Fashion for Super Heroes'. Cape: Catherine Chaillet for Benjamin Davy, 1966. © London College of Fashion/The Woolmark Company.

'I think they're all mad'

SHOPPING IN SWINGING LONDON
SONIA ASHMORE

In *Time*'s mythical Swinging London, a tribe of 'guys and dollies' swarmed from Portobello market to the King's Road boutiques every Saturday in a *passeggiata* of display and mutual admiration.[1] While the reality was more layered, the clothes shops that they were pictured visiting were key sites in the making and diffusion of a 1960s look. They were closely identified with a newly recognizable and supposedly classless youth culture. These shops, every bit as much as the clothes and the music of the period, are etched deeply into the memories of the generation who were young adults in the 1960s.

According to *Get Dressed: A Useful Guide to London's Boutiques* by 1966 there were at least 80 such shops in Central London alone. In Jonathan Aitken's estimation there were perhaps more than 2,000 in Greater London as a whole.[2] In the spirit of the times, even the contemporary evidence was hazy. *Get Dressed* defined the boutique, a word of eighteenth-century French origin, as 'a small informal shop, probably run by the proprietors, selling mostly exclusive fashionable clothes and accessories'.[3] The book was endorsed by Mary Quant, who preferred to use the word 'shop'; 'I hate boutiques', she wrote in the Foreword.

In the post-war period the London fashion retail trade followed stratified pre-war models, with distinct shopping zones and streets, from populist Oxford Street, to Bond Street and Knightsbridge, with their aura of money and class distinction. Elite fashion was led by Paris couture or its London counterparts. It aspired to quiet good taste, seasonal clothes made to last and value for money. Fashion shops ranged from the couture salons of Mayfair to department stores that were often formal, even daunting, with uniformly dressed sales assistants set on dressing young people like their parents, who generally accompanied them. Chain stores aimed for a 'nice and neat' version of respectability.[4] In between were the 'madam' shops, gown and mantle shops, costumiers, ladies' or gentlemen's outfitters, and innumerable small drapers that also sold hosiery, underwear and separates. After wartime shortages and post-war austerity, almost anything would sell.

The 1950s version of the boutique was a rarefied place with an air of Parisian chic.

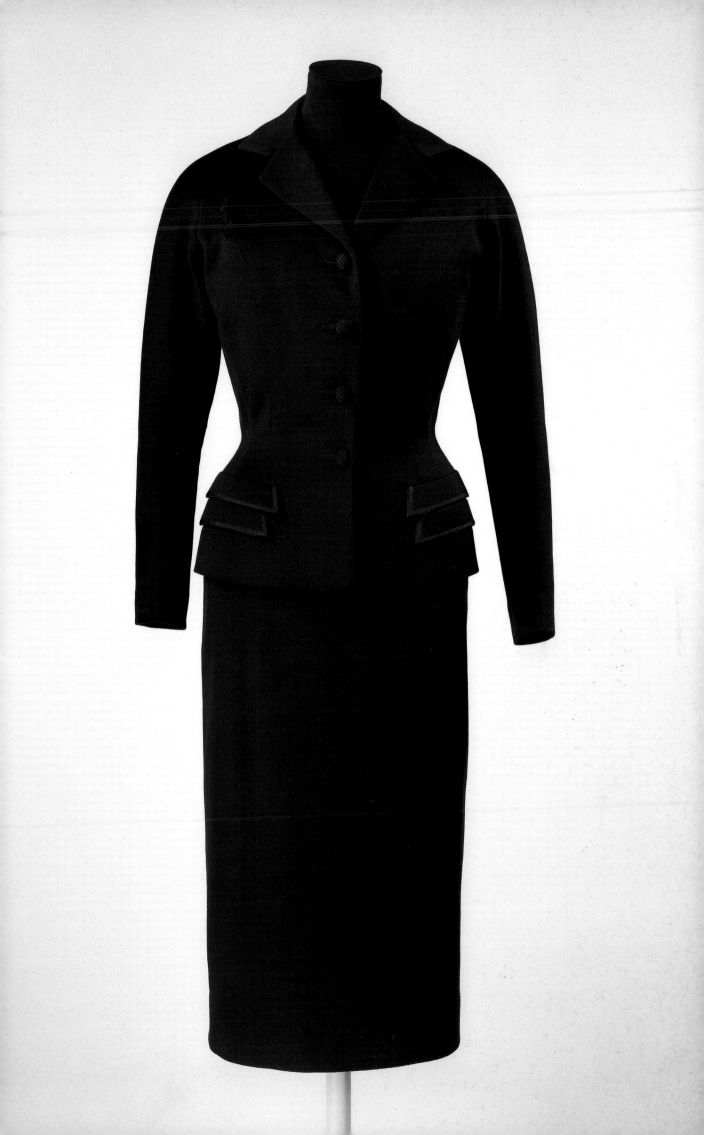

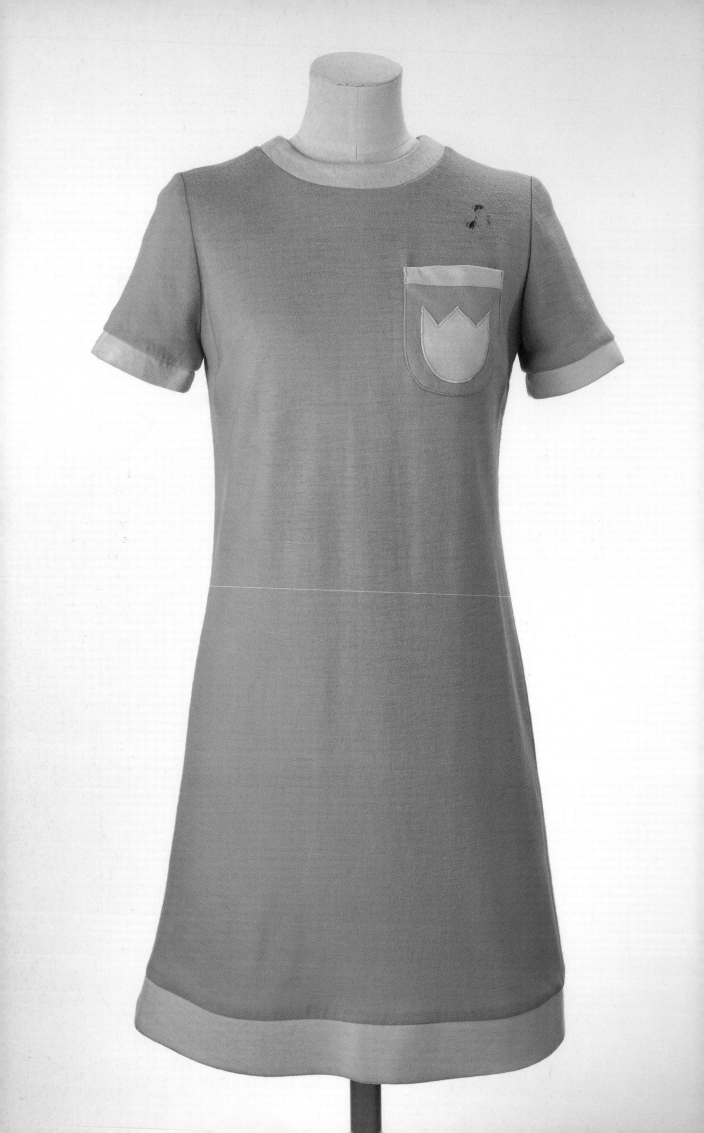

Vogue noted that several London houses 'have now opened these entrancing little shops in their salons',[5] and reported regularly on the latest amusing independent shops in Mayfair, Belgravia or Knightsbridge. Department stores such as Peter Jones and Bourne and Hollingsworth also opened 'boutiques', and chains of small, boutique-like shops expanded, aiming at an affluent middle-class market. The first boutiques were places 'where you went to buy things that you could not get anywhere else', but were exclusive and expensive. 'They completely failed to connect with the demands of new, younger customers … what was needed was a combination of madam shop – good on sizing, the boutique – for unusual items and accessories, and the couturier – for new designs.'[6]

In 1950, British Vogue's ideal woman was dressed by London designers, lived in the country, drove a car, went shopping, lunched out, sat on committees, dropped in for drinks, went to Ascot, gave parties, and holidayed abroad.[7] Even Vogue's 'Young Idea' section, launched in the mid-1950s, showed 'Clothes for the Season'. Yet by the late 1950s, social and demographic changes meant that the wider clothing trade had to acknowledge the pattern of fashion set by teenagers;[8] to most of them, the 'Season' meant nothing. Even Vogue had spotted the 'teenage thing', a look with 'urban and working class' origins.[9] As the New Statesman commented, this trend reflected 'full employment and a relatively high level of income among adolescents'[10] which allowed them to challenge the values of their elders. These 'baby boom' teenagers may have been invented by and for capitalism; but they were happy not to dress like their parents and to be guided by new magazines written for their own age group. By 1966 the magazine Honey had its own branded boutiques in nearly 50 stores. Advertisements were increasingly aimed at smart young girls with money to spend. The introduction of credit cards made spending easier, and in 1966, Barclaycard was advertised as 'all a girl needs when she goes out shopping'.

As Jenny Lister suggests, the impetus for changes in clothing and shopping styles also came from a new generation of designer entrepreneurs. These included Mary Quant, who with Alexander Plunket Greene and their business partner Archie McNair, opened Bazaar on the King's Road in 1955, John Stephen

Opposite Ginger Group (Mary Quant), dress. Wool mix jersey. British, c.1967. Given by Mrs Lina Salmon. V&A: T.86–1982.

Right Ginger Group label from dress, 1966. V&A: T.89–1982.

and his imitators on Carnaby Street, the young designers emerging from British art schools, and Barbara Hulanicki, creator of Biba. The combination of design energy and retail opportunities meant that by the late 1960s, the women's magazine *Nova* could state, 'what Paris couturiers say has nothing to do with the way you and I are going look this winter. How you will be dressing depends mainly on the influence... of our own designers.'[11] These were Barbara Hulanicki, Foale and Tuffin, Jean Muir, Ossie Clark and Alice Pollock, all of whom ran their own shops.

Bazaar, the prototypical new-wave women's boutique, at first bought in clothes and accessories, but soon became a showcase for Quant's own designs, originally made with adapted commercial paper patterns and fabric bought in Harrods.[12] Production of garments was at first on a small scale, in Quant's Chelsea bedsit. This pattern was not uncommon, and manufacturing also took place above the shop, as in Ossie Clark's workroom above Quorum, in Chelsea. Sylvia Ayton and Zandra Rhodes began their business in Ayton's flat in 1966. Ayton later commented that they started the Fulham Road Clothes

Shop because 'buyers were not always on the same wavelength, so it was essential to go straight to the customer'.[13] John Stephen started making and selling men's clothes in an upstairs room in Beak Street in 1957, moving into Carnaby Street after a fire.

Both Quant and Stephen had a talent for publicity. Bazaar had a party atmosphere; its windows were dressed outrageously to attract attention on a street where, as Quant remembered, people 'were not necessarily shoppers... we had to make a sharp, shocking statement at the beginning to be noticed at all'.[14] The most famous display had a mannequin leading a giant lobster on a gold chain. Quant, with her trademark Sassoon haircut, evolved into a human logo for her global business. Stephen was photographed with the symbols of his success strategically in shot. The Rolls Royce, the sharp suits, and above all Carnaby Street itself, created the image of a new kind of retail tycoon. He gave innumerable interviews, had columns in the popular press, featured as a 'pin-up' in teenage magazines such as *Boyfriend* and was promoted as the 'King of Carnaby Street'.[15]

Left John Stephen. Advertisement using Carnaby Street sign, 1968. V&A: AAD JS 1998/5/7.

Opposite 'Window dressing at Bazaar, 138a King's Road'. 1959. © Getty Images.

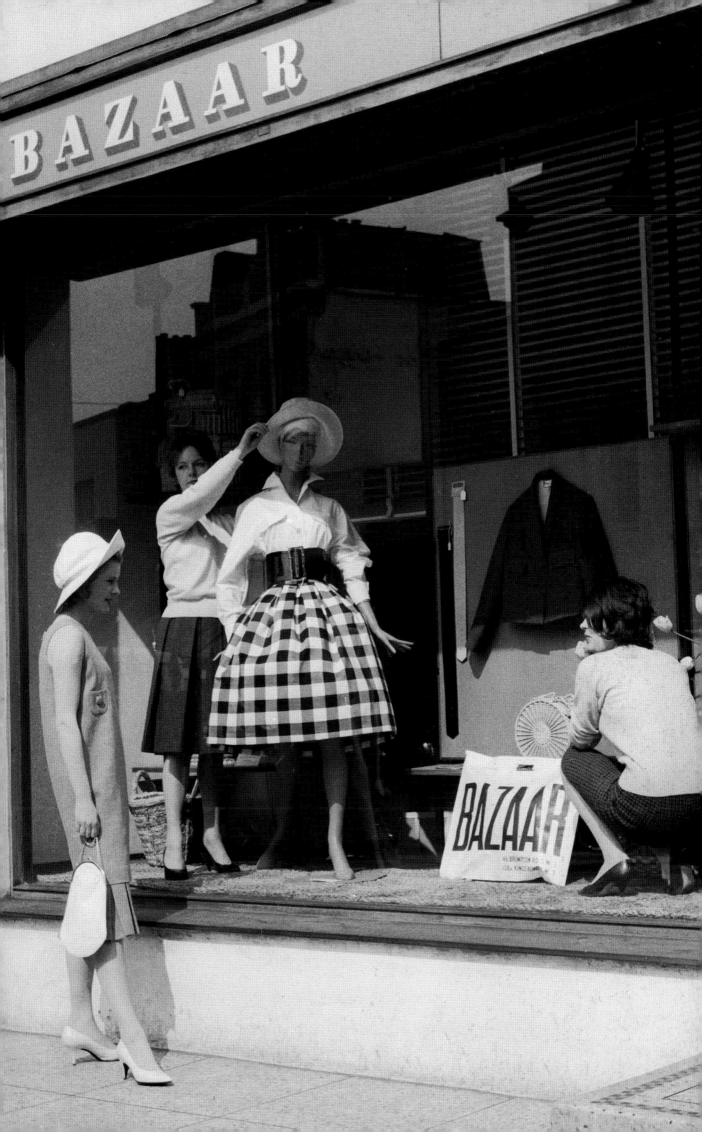

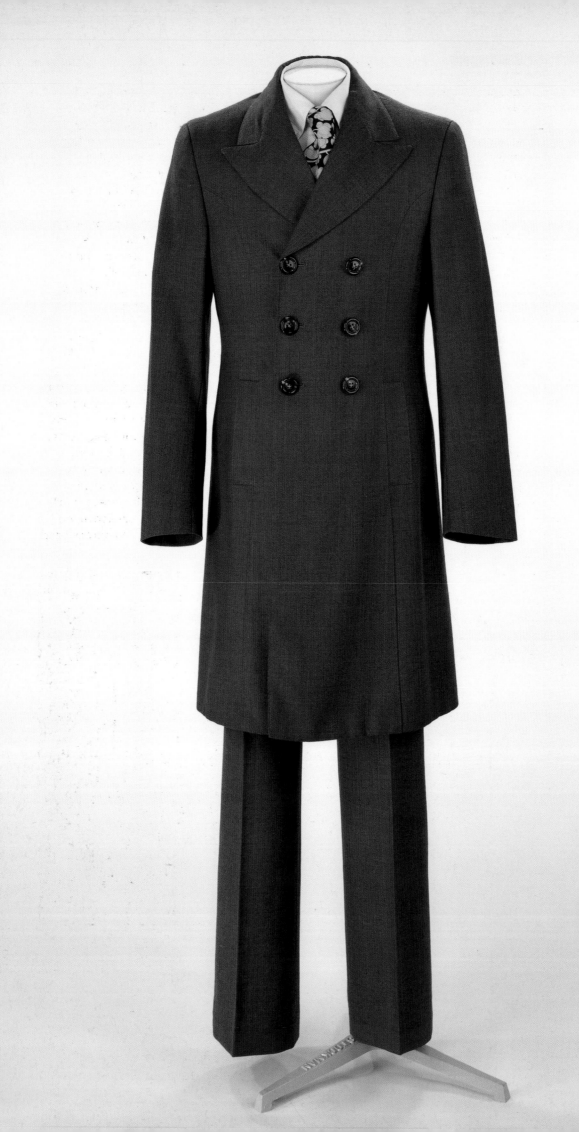

Despite the frequent emphasis on the 'dolly bird' as the archetypal new fashion consumer,[16] young men were key patrons of innovative retailing, led by Stephen, who recognized the sharp sartorial ambitions of the Mods. Borrowing from Vince, the men's shop run by physique photographer Bill Green, Stephen took what were essentially homosexual dress codes into the fashion mainstream 'as a modern and optimistic trend, unbounded by sexual orientation'.[17] The effect was both liberating and successful. Until 1965, when Stephen opened Trecamp, his first women's shop, the Carnaby Street boutiques were squarely targeted at the male consumer: The Man's Shop, Adam, His Clothes, Male West One and Paul's. Trecamp disrupted this strict gendering of the street. Its changing rooms were dominated by enormous photographs of half-naked 'musclemen' that might easily have been perceived as homoerotic images. Even heterosexual men were encouraged to take a narcissistic interest in fashionable body styles by similar sexualized displays. Through such provocative strategies, Stephen had established Carnaby Street as a source of modish, youthful and 'unisex' fashion – a true 'street' style.

John Stephen was not a trained designer, but came into fashion through retail. He observed his customers closely, noticing girls trying on boys' clothes and introducing the modifications they wanted. A brilliant marketer, Stephen even sold 'mini-kilts' to men in his 'Highland Shop', bottle of whisky included. 'I think they're all mad,' he admitted, 'I wouldn't have the guts.'[18] He preferred subtle tailored clothes, unlike Quant who wore her own flamboyant designs. Yet both Stephen and Quant promoted modernity, while designers such as Ossie Clark and Barbara Hulanicki embraced period revival.

The fashion boutiques that rapidly followed Quant and Stephen ignored Paris, had little to do with couture, and sold clothes that were often shocking to an older generation for their brevity of scale and skimpiness of manufacture. They tended to be small, intimate spaces, often with a strong interior and exterior design style. The clothes were profligate with styles and fabrics, and easily accessible on open rails. The job of shop assistant brought with it a new sense of glamour; the staff dressed much like the customers, rejected subservience, and sometimes service too. They were characterized

Opposite John Stephen, suit. Worsted wool. British, c.1970. Given by John Stephen. V&A: T.214-D–1997.

Right Bus Stop boutique, Kensington. 1970. © Getty Images.

by spontaneity, a sense of fun, informality and sometimes by amateurishness, and lack of capital or business knowledge.

By the early 1960s, the boutique effect had spread from the King's Road and Carnaby Street to Kensington, where Bus Stop and Biba were located. Lee Bender opened Bus Stop in a former Cullen's grocery store on Kensington Church Street; painted bright red and gold, it was the first of 12 Bus Stops. Close by, Hulanicki opened the second Biba shop in the old Home and Colonial stores; the shop had a nostalgic feel and many of the original fittings were retained. The boutique effect also reached Hampstead and Blackheath, home to new celebrities such as Jean Shrimpton and Terence Stamp, where Jeff Banks opened Clobber in 1964. Despite the new myth of classlessness, there was a hierarchy to these shops that was partly about money and partly about that nebulous quality 'cool', crucial to the mystique of shops such as Granny Takes a Trip, which sold almost anything but fashion. Shops such as Annacat were run by and for debutantes. Socially well-connected shops such as Michael Rainey's Hung On You in Chelsea catered to the male dandy and wealthy bohemian. Blades, in Mayfair, was like a 'grand club', where suits cost upwards of £70.[19] A new elite of pop musicians and their entourages was crucial to the success of certain boutiques. Top Gear and Countdown were two tiny shops opened by fashion model Pat Booth and milliner James Wedge at 135a–137 King's Road in 1964. They attracted a celebrity clientele and sold clothes by young designers, proving to be an important source of patronage to Ossie Clark, amongst others. Other shops, including Just Looking and Biba, were more populist and much less expensive. At Biba, Hulanicki sold to a mass market, initially by mail order. Her dresses cost just £2–3. Many girls were spending more than twice that a week on clothes, half their new wage packets.[20] Before metamorphosing into supermodel and archetypal 'dolly girl' Twiggy, the teenage Lesley Hornby would dash from her Saturday job at a hairdressers' salon in Queensway to Biba, then a tiny shop in Kensington, where even as an unknown Neasden schoolgirl, 'you could afford to buy something every week' in your lunch hour.[21]

Twiggy's strategy reflected the geography of the new boutiques, which incorporated streets and back alleys of the city not previously associated with fashion, except through its manufacture in

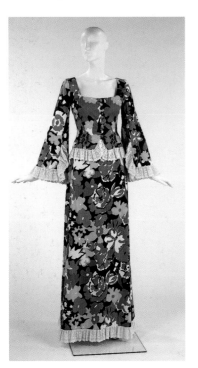

Far left Annacat, dress. Printed cotton. British, 1970. Given by Mrs David Bruce. V&A: T.6&A–1974.

Left Top Gear boutique, King's Road. 1966. © Getty Images.

Above Mirandi (retailed
at Hung On You), jerkin.
Suede. British, 1968–9.
Worn and given by Mr David
Mlinaric. V&A: T.313–1987.

Above Barbara Hulanicki (Biba), jacket. Synthetic with gold lamé. British, 1968–70. V&A: T.82–1991.

cramped tailors' premises behind the grand retail thoroughfares of Oxford and Regent streets. Just as Bazaar had a galvanizing effect on the economic geography of the King's Road, so Stephen's initiatives transformed the dingy hinterland of the West End. There was a sense of excitement, discovery and ownership about these new spaces. Granny Takes a Trip, opened in 1965, was 'round the bend' of the King's Road at World's End, quite a walk from the main beat and scruffier, although curiously exclusive. There were also clear class differences between the King's Road and Carnaby Street. Quant's customers were well heeled – her 'set' was not working-class. Thus the King's Road was not for real Mods. Carnaby Street took on the cheap glamour of its Soho environs, not the social cachet of Chelsea. And there were markets: Portobello in then rough Notting Hill; undercover Kensington, safe from the elements, and Chelsea Antique Market for superb old clothes.

The success of Carnaby Street fascinated the press because it broke retailing norms. As the *Investors Chronicle* remarked: 'It's hard to find, you can't park, all the shops depend on the same market, compete directly, there is no conventional advertising… How does it succeed?'[22] It had 'small, closely controlled production lines' allowing frequent innovation; Stephen made up to 60 per cent mark-up and took cash only. His little empire was also part of a wider expansion of men's tailoring that brought the *idea* of Savile Row to the working-class boy, but styled with Italian chic and dandified touches. The area attracted 'ex-Savile Row men… who… make suits for Polanski, Stamp, Curtis, Caine and other heroes of our time. If they don't make your suits man, you just don't rate,' as the *New Statesman* commented.[23]

The establishment succumbed in other ways. In one sense the kitsch Carnaby Street stood in opposition to the reform of more mainstream retailing along slick modernist lines. Austin Reed's Cue, Woollands' 21 Shop and Simpson's Trend, all aimed at an affluent market, were examples of this purer boutique aesthetic. By 1966, however, even avowedly modernist *Design* magazine was celebrating the design style that had emerged from the boutique movement as a truly popular one, but presenting it in a modernist format. In their feature Kate and Ken Baynes recognized

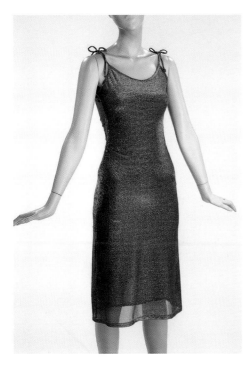

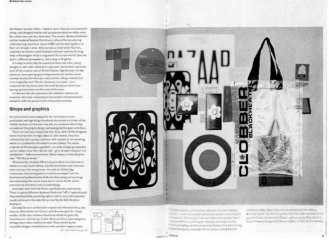

Left Rose Bradford for Quorum, dress. Synthetic mix with lurex. British, c.1968. Given by Louise Barber. V&A: T.463–1988.

Above '*Design* features boutiques', *Design*, August 1966, pp.22–3.

Carnaby Street as the 'birth, however illegitimate, of a really thoroughgoing design movement', claiming that, 'one day, "Carnaby Street" could rank with "Bauhaus" as a descriptive phrase of a design style and a design legend.'[24] Yet only two years later the magazine noted that 'Carnaby Street and all it stood for is no longer a spearhead of design innovation.'[25] At the very moment when *Time* attempted to define London as 'swinging', the boutique's creative heyday was already over.

By 1966, one boutique generation had grown up. Vanessa Denza, whose buying had helped define the innovative, youthful style of Woollands' 21 Shop and launched several young designers, opened a shop in Sloane Street with Madeline Frye, selling clothes to career girls and young married women over 25, not swinging single dollies. Mary Quant had become an international mass-market brand in the United States, and boutique chains occupied the King's Road; John Stephen owned 22 boutiques and had also expanded to the US. Carnaby Street was less about tailoring than souvenirs embellished with Union Jacks, a trend started by John Paul of the Portobello Road shop I was Lord Kitchener's Valet. By

1969, two out of three Quant shops had closed and the King's Road site sold. In 1966 Irvine Sellars owned a chain of boutiques and was exporting to the US, but within a decade his chain of 200 shops was in receivership. By the mid-1970s, many boutiques had transmuted into the 'jeans shops' that flooded Oxford Street.

Boutiques were frequently short-lived; the trade press carried a litany of disaster: '…put savings into boutique with disastrous results', 'overbought through inexperience', 'drew too much money from his boutique', 'failure due to inexperience.'[26] Extravagant lifestyles and drug habits ensured the ruin of others. Palisades, with its jukeboxes and fruit machines, lasted two years; its owner, Pauline Fordham, one of the 'swinging' Londoners featured in *Time*, who had started with Foale and Tuffin, two of *Time*'s 'top happeners', blamed the intrusion of department stores.

By the mid-1960s, the antithetical values of the boutique had been fully appropriated by the mainstream retail trade. In 1959, Austin Reed had presciently rejuvenated its image by commissioning young RCA graduate Robyn Denny to paint a huge 'pop' mural for the

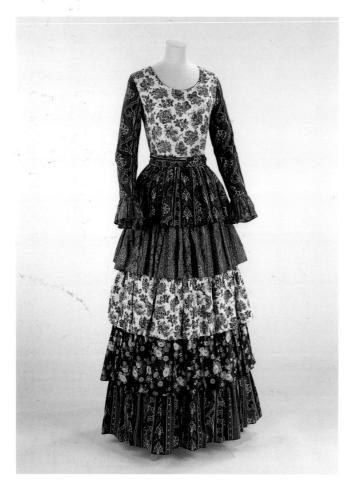

Left Countdown, dress. Printed cotton and mixed fibres. British, 1970. Given by Jill Ritblat. V&A: T.728–2000.

Above I was Lord
Kitchener's Valet,
Portobello Road. 1966.
© Getty Images.

Regent Street shop, a stone's throw from Carnaby Street. Other upmarket clothing retailers such as Jaeger and Simpson had followed with departments aimed at 'younger' customers. In 1966 Selfridges owner Charles Clore brought the boutique style into the department store by investing a million pounds in Miss Selfridge, a huge, shiny 'boutique'. Although its vast scale was the antithesis of the original boutiques, it was aimed specifically at young women under 25 whom it saw as captive future customers. Harrods' Way In opened the following year featuring an internal 'street' of 'boutiques' selling fashionable clothes to well-off young men and women. It covered 20,000 square feet, and its new cash registers were each able to take the unprecedented sum of £999.99 in a day. Independent Top Shops were opening by the early 1970s, gradually replacing the parent Peter Robinson fashion stores. But by mid-decade, even Way In 'became yesterday's news', according to its former chief cashier. The paintwork of its 'Quink Blue gloom',[27] 'became chipped and dirty... many of the original concessions long gone... the chrome and white [refit] which replaced the blue seemed to spell the end of an era, the finish of the swinging sixties and of one's own youth departed.'[28] Pontings, a once popular department store in Kensington High Street sold off remaindered boutique wear before being closed down entirely by House of Fraser in 1971.

In the early 1950s, Carnaby Street had been 'an almost sleazy little street of one-room workshops or unplumbed apartments, whose broken windows hung with threadbare lace curtains... There was a population of women in carpet slippers, their dressmaking pins bordering the straps of their working aprons, and craftsmen-tailors whose stock-in-trade was alterations.'[29] By 1966, 'boutiquers' such as Warren Gold with his aspirationally named Lord John chain, had followed Stephen like miners to a goldrush, and were collectively making £5 million a year. Rents had multiplied tenfold. The capital value of the area had been transformed. Tourists flocked there. As the *Glasgow Herald* reported: 'The zest has gone from Carnaby Street... the loss of vision in the street means that male fashion is at the moment without a leader... become respectable... Big Business, the Establishment of the outfitting world, has moved in. Every

Opposite Juliet Glynn Smith, psychedelic poster for D.H. Evans. 1968. V&A: E.868–1968.

Left 'Pontings: boutique clearance sale', *Evening News*, 7 July 1968. © Museum of London.

Above Oxford Street gets up-to-date: an advertisement for Peter Robinson's Top Shop featuring Twiggy dressed in new synthetic fibres. *Vogue*, November 1966, pp.72–3.

store now has its male boutique offering twopence-coloured reproductions of Carnaby Street styles without the novelty, the gaiety or the zaniness that typify the originals.'[30] In the early 1970s, in a sign of the changing times, Stephen's company passed into the world of commodity trading. The street renounced its fashion credibility as it became a marketable entity, pedestrianized in 1972, with coloured plastic tiles added the following year. By 1983 the Crown Estate had bought up and then sold the entire west side. It had become a depressing cipher for Swinging London.

Yet, at the very moment when the boutique appeared to be dying, and stores had 'nearly worn themselves out dividing up their acreage into imitation boutiques',[31] Barbara Hulanicki expanded her own style of boutique into an entire redundant department store. Derry and Toms on Kensington High Street was one of Victorian Kensington's temples of consumption whose splendid but neglected Art Deco modernization was appreciated and exploited by Hulanicki. Beautifully detailed design was applied to every aspect of merchandise, furnishings, marketing and packaging, playfully celebrating nostalgia.

The 1973 Biba also performed 'the valuable service of raising fundamental questions about what a department store should be', in terms of public space and spectacle.[32] Eventually killed by conflict between creative ambition and corporate ownership (Dorothy Perkins and British Land), Biba was, temporarily, a place of pilgrimage; glamorous and camp enough for rock stars, yet cheap enough for a 15-year-old schoolboy from Somerset to buy 'gold sparkly Wellington boots' to wear at home on the farm.[33]

The alternative values of the 'Sixties generation' were not limited to clothing styles, which, by the end of the decade had embraced other-worldly exoticism. Conflicting attitudes to post-war affluence were epitomized by the bomb planted in the previous Biba store by the anti-capitalist 'Angry Brigade' in May 1971.[34] The Brigade's 'Communiqué 8' was a crude if passionate critique of the new consumerism, paraphrasing the counter-cultural lyrics of Bob Dylan. 'If you are not busy being born you are busy buying… Life is so boring there is nothing to do except spend all our wages on the latest shirt or skirt. Brothers, sisters, what are your real desires?'[35] For some the

Left Biba, Kensington Church Street. c.1966. Courtesy of Philip Townsend.

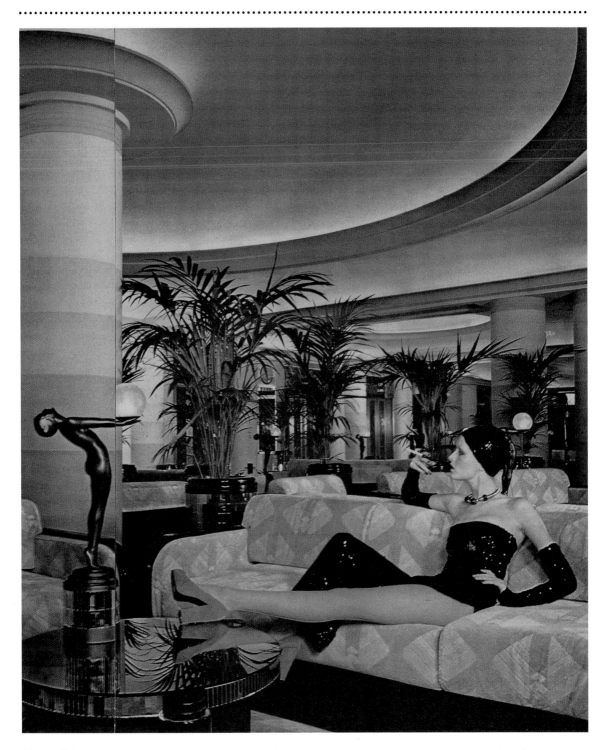

Above Twiggy
photographed by Justin de
Villeneuve in Biba's Rainbow
Room Restaurant in the
former Derry and Toms
department store, c.1973.
V&A: AAD1996/6.

View from behind double curvate
reception desk shows complicated s
of coffee-coloured grp skin. Holes i
ceiling accommodate downlighters
were also points at which the shelf
hooked onto crane, left. Archway be
cash desk leads into hairdressing s
Floor and shopfront are both clad in
pvc sheet

desire was clearly to carry on consuming; customers escaping from the bomb were picking up as much merchandise as they could hide under their clothing.

Boutiques, like any shop, were inherently ephemeral and changing. By the early 1970s, even the couture industry had opened freestanding boutiques, led by Yves Saint Laurent with Rive Gauche in 1966. From the remnants of Swinging London, the next 'angry' generation shocked its predecessors with ripped clothing and body piercing. They were encouraged by the new Chelsea entrepreneurs, Vivienne Westwood and Malcolm McLaren, who in 1971 established themselves on the spot to which Hung On You had moved in its hippy phase, and Tommy Roberts' Mr Freedom had sold brightly coloured pop clothes, just on that cusp where the King's Road went into wilder territory.

The fashion boutique was an essential part of the iconography and the physical landscape of Swinging London. Innovative, informal and often ephemeral, boutiques attracted and informed a new generation of fashion consumers and a considerable tourist trade. They challenged the orthodoxies of shop organization and design. Fun, eclecticism and novelty prevailed over functionalism, ergonomics and quality. Music became an integral part of the experience of fashion consumption and clothes shopping returned to its pre-war incarnation as an activity associated with entertainment and spectacle. Yet the innovative styles of garment, shop design and graphics pioneered by the boutiques of the mid-1960s were inevitably copied by larger stores, and small independent shops were developed into chains and brands. While this stifled their spontaneity and formalized their design style it also encouraged a more creative approach to the design of other shops, and introduced a greater responsiveness to the consumers of fashion.

Opposite Bootique, a prefabricated boot-shaped interior eased into the Vidal Sassoon hairdressing salon in Old Bond Street. *Design*, 1 February 1971, p.59.

The Boutique Look

Boutiques used appearance as advertisement and self-definition. Many of them broke with conventions of professional design, adopting the magpie tendencies of Pop Art. Sometimes this amounted to little more than crude populism. John Stephen's shops, for all their novelty value, were not high-design statements; they were generally crowded, with clothes on open rails, the street façades disguised with garish theatrical effects. Some used topless models in their shop windows, exploiting the new culture of permissiveness. Quant also insisted on vulgarity over good taste, although Bazaar's idea of bad taste was rather more sophisticated than Carnaby Street's. Bazaar had set the pace by inserting a modern plate-glass window into a Georgian terrace. Great effort was spent on its promotional displays, which were consistently witty and wild. Other retailers attached temporary façades. The exterior of the Beatles' Apple boutique on Baker Street caused controversy with its 40-foot 'psychedelic' exterior mural. In 1968, Granny Takes a Trip took the prize for shock value with one of its frequent face-lifts: a vintage Dodge car apparently bursting through the shop's façade. Elements of Pop and Op art, Victorian and fairground lettering and revivals of Art Nouveau and Art Deco were used by many shops to create a strong, irreverent display style.

While some retailers made do with an effective if ad-hoc mix of junk-shop furniture, which developed into the stylish eclecticism of Clobber or Biba, others preferred a more coherent contemporary image. Some went for new versions of modernism. Countdown on the King's Road had a silver metal interior. Foale and Tuffin's shop, off Carnaby Street, was all white with lots of sliding mirrors floor to ceiling, wth clothes hung on scaffolding construction and lit by 500 red, white and blue light bulbs. Others were drawn to fantasy themes. The exterior of Palisades, Ganton Street, was painted in fairground style by artist Derek Boshier; inside, all was clashing colours, pinball tables, flashing lights and a working jukebox. Barok, a men's shop on the Earls Court Road had gold walls, Op art and a water fountain. Gerald McCann's design for the John Michael shop on the King's Road, while sharply modernist on the outside, had theatrical suede curtains, hessian walls, aubergine paint and bronze fittings. Nearly all the shops had jazz or pop music playing. This was a novelty and depended on the assistants putting records on turntables. Communal fitting rooms became the norm – even at Harrods' Way In, where they reminded some of French public urinals because the walls did not reach the ground. At the end of the 1960s, Biba was to take design to new extremes of 'retro' refinement.

As boutiques became big business, their construction and styling became ever more elaborate and brand-conscious. 'House style' became the catchword. From a do-it-yourself activity, the design of everything from clothes to carrier bags became a professional task performed by in-house design teams and outside consultants, which packaged these local enterprises as national and global brands.

Below Biba labels, from the store in the Derry and Toms building. John McConnell designed the original logo; Whitmore-Thomas set the house style for the new store. V&A: AAD–1996/6/53.

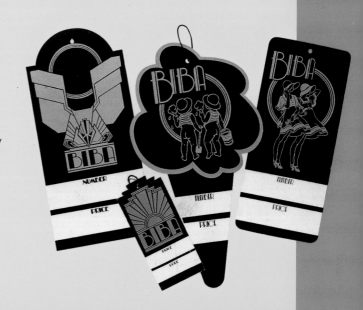

Left Royal College of Art fashion design graduates Marion Foale and Sally Tuffin (both seated, Tuffin left, Foale right) opened their shop off Carnaby Street in 1962 because the rent was cheap. *Vogue*, April 1965, p.14. Michael Wickham/*Vogue* © The Condé Nast Publications Ltd.

Below left Hung On You, 1966. Michael Rainey's shop catered to hip, well-off young men. In the late 1960s it moved from Cale Street, Chelsea to 430 King's Road, subsequently home to Mr Freedom and then the Vivienne Westwood and Malcolm McLaren shops. © Getty Images.

Below right Two illustrations for Biba by Kasia Charko. V&A: AAD–1996/6/4.

Myths of the Swinging City

THE MEDIA IN THE SIXTIES
PAMELA CHURCH GIBSON

Opposite Twiggy (Lesley Hornby) with her mother Helen Hornby, 1965. Photograph by Terry O'Neill.

The 1960s was perhaps the first decade created in the media. It was 'invented', chronicled and examined whilst it was unfolding, rather than labelled and analysed with the benefit of hindsight. The only other decade to excite so much contemporary discussion was the so-called 'Roaring Twenties'. Both decades saw radical, irreversible social changes and a liberalizing of attitudes. Both were particularly notable for the new behaviour of women, many of whom no longer contemplated a future defined through marriage and domesticity. And in both decades, startling new modes of dress reflected these desires and freedoms. However, the comparatively underdeveloped media of the 1920s could only chronicle the antics of the 'Bright Young Things' and depict the new fashions of the flappers. The media did not yet have the capacity to shape their careers or to widen their sphere of influence. But 40 years on, the media were powerful enough to promote the activities of those involved in the 'Swinging London' they had christened, radically increasing the reach and significance of these cultural changes. Most importantly, they now possessed the capacity for self-reflexivity and change – the media that showcased the phenomenon of the 'Swinging Sixties' were also transformed by, and reconstructed in, this uniquely influential decade.

Over the course of 10 years, new magazines appeared that had different readers in mind, and looked quite unlike anything that had preceded them. The revamped *Vogue* and the new-look *Queen*, radically altered by its new editor Jocelyn Stevens to suit the changed climate, were still catering for an older, middle-class market. Stevens had purchased the magazine in 1957 and employed as layout artist and assistant editor Mark Boxer, recently sent down from Cambridge for blasphemy after a highly controversial poem appeared in the student magazine, *Granta*, during his editorship. Boxer and Stevens transformed the appearance and content of the staid magazine into something more modish and cutting-edge. As a result, Boxer was tempted away by a huge salary offer to supervise the new *Sunday Times* colour supplement. All these changes, however, had nothing much to offer teenage girls, particularly working-class girls, who were now the main target for magazine publishers as well as high-street retailers. *Honey*, which first appeared in 1960, had

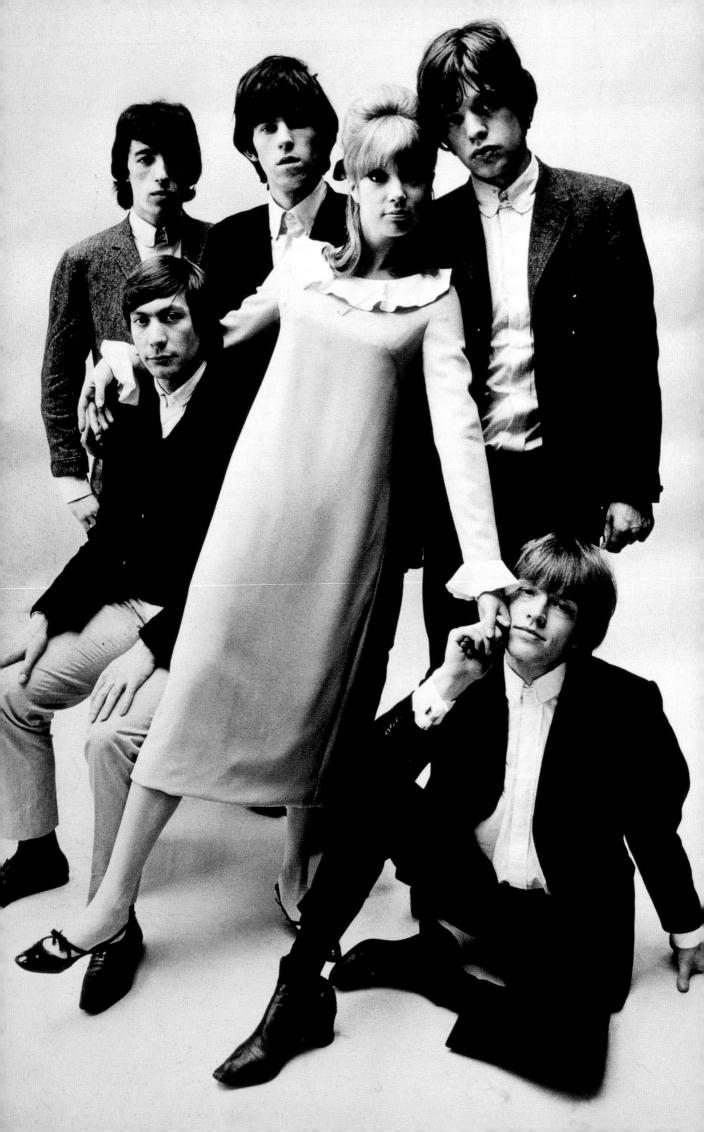

a circulation of 200,000 by 1966. It was not merely a showcase for fashion – instead, the editorial staff concerned themselves with the realities of life for young people outside the charmed circle configured in the metropolitan media. They ran articles on leaving home, flat-sharing, premarital sex, living with a man out of wedlock and, when the contraceptive pill became widely available in the mid-1960s, they discussed its pros and cons. Work figured too. Careers were profiled and scrutinized, along with office politics. *Honey* also lent its name to a series of out-of-London shops-within-shops so that their readers could find the clothes they wanted to suit their new ideas of independence.

Honey appeared monthly, but a new weekly magazine, *Petticoat*, was even more successful. Launched in 1966 and specifically aimed at younger girls, it featured cheap, desirable clothes and inexpensive, widely available accessories. Its strapline announced that the magazine was 'for the young and fancy-free', and a column, 'Cathy's Crowd', recorded the diary of a young girl up from the provinces and sharing a flat in London. The flatmates support each other through every crisis, serious or otherwise. To keep abreast of current fashion, Cathy purchases a 'fun fur' from a stallholder in Portobello Road. Sadly, it disintegrates in the rain – the skins are stuck together with Copydex. This is mildly distressing – but far more problematic is her two-year campaign to preserve her virginity, constantly under siege from older boyfriend, TV producer David. This saga runs in tandem with that of plump flatmate Sue's unhappy sexual liaison with her married boss, to whom she succumbs and whom, she hopes, might leave his wife.

However, the most innovative and commercially successful elements of the winning formula that set *Petticoat* apart were its colourful fashion pages and features. There was comprehensive coverage of the new music scene, while its star profiles and interviews, whether with musicians or film actors, always featured those who were young and of the moment. It was summed up by its distinctive lowercase logo, a visual indication of the contents – the dot of the 'i' was shaped like a daisy, while the cross of the 't's was replaced by flat bows, like those on the front of a 'dolly' dress or adorning a pair of the new square-toed shoes.

Opposite Patti Boyd in Mary Quant (Ginger Group) crêpe 'Alice' dress with frilled collar and cuffs, pictured with the Rolling Stones. John French, April 1964.

Petticoat was launched and funded on a shoestring and faded as the 1960s died, finally folding in 1975. Its editorial staff had a more lasting effect on London's fashion culture. Janet Street-Porter became an innovator in youth television during the 1980s, Eve Pollard went on to edit the *Sunday Express*, and Lynne Franks dominated London's fashion public relations industry for many years (before being immortalized as Edina in the television series *Absolutely Fabulous*).

Broadsheet newspapers also changed their approach and format as well as modifying their content. The liberal *Observer* cast an optimistic eye over the changing scene, and Katherine Whitehorn, its fashion editor, was swift to identify and champion new designers. *The Times*, in its pre-Murdoch days, was still the bastion of the establishment. It looked in 1960 much as it had done in the Victorian era. However, on 3 May 1966 the paper finally shifted the main news stories to the front pages, replacing the announcement of 'births, marriages and deaths'. Far more astonishing, however, was the political stance *The Times* adopted in 1968. In its coverage of the Rolling Stones' trial for the possession and use of illegal drugs, it came out staunchly in their defence. William Rees-Mogg, the editor, wrote an eloquent first leader, which sought for 'Mr. Jagger' the same justice that would be 'thought proper for any purely anonymous young man' and gave it by way of a title an epigram from Alexander Pope: 'Who Breaks a Butterfly Upon a Wheel?'.[1] Of course, the more traditional and timorous papers – the *Daily Express* and the *Daily Mail* – fed the fears of their 'Middle England' readership and constantly bemoaned the seeming collapse of civilization. But they always put the more sensational examples of this 'collapse' on their front pages, as did all the dailies, whether right-wing or left-leaning. Each of the new excesses – whether it be the annual battles between Mods and Rockers at Margate, the extraordinary phenomenon of what was christened 'Beatlemania', or the rise and rise of the miniskirt – was carefully chronicled.

Changes in newspaper format were often radical and experimental in themselves. The first *Sunday Times* colour supplement appeared on 4 February 1962 and had, on its cover, repeated Polaroid-style shots of a new, young model, photographed by

Opposite Jean Shrimpton at Tower Bridge. 1961. An early photograph in which Shrimpton, dishevelled and slightly bruised, is intended to look 'just-out-of-bed'. Photograph by David Bailey.

her boyfriend, a Cockney photographer who was making a mark on the fashion scene. The model was Jean Shrimpton, the photographer David Bailey. Where John French had made her look elegant and mature, Bailey chose in this shoot to emphasize her youth and to show her with very little make-up. Shrimpton's hair was tousled and the dark circles beneath her eyes clearly visible, not painted out as they had been in earlier pictures. This shoot was a career-defining moment for both of them, and established their partnership as central to the changing fashion industry.[2]

Bailey was one of the self-styled 'Terrible Three', who came to prominence early in the 1960s. His companions were Brian Duffy and Terence Donovan, and they chose this nickname in order to emphasize their irreverent attitude, their cheeky behaviour in the sacrosanct world of high fashion and their consistent refusal to conceal their sexual interest in the models.[3] Previously, fashion photographers had been well-heeled, well-bred young men, often rather camp in demeanour. As Donovan observed, 'they were tall, thin and homosexual – we're short, fat and heterosexual.'[4] He also clarified their

reasons for presenting models as relaxed, untidy, even as sexually available and with, perhaps, that 'morning-after' look: 'We try and make the model look like a bird we'd want to go out with.'[5] The journalist who was interviewing him – for The Sunday Times supplement, which devoted a special issue to 'Taste' – went on to explain to readers outside the world of fashion that 'very often, the model and the bird are the same girl'.[6] In the past, fashion photographers – with the exception of Antony Armstrong-Jones, who married Princess Margaret – had been anonymous figures. However, these three – particularly Bailey – became as well known as the 'birds' they chose to photograph. A popular rhyme of the period suggested that 'David Bailey makes love daily'. Each new girlfriend he chose found herself profiled and depicted outside the safe confines of the fashion magazines.

Models, too, were changing – not only in appearance but also in their ability to influence style. Jean Shrimpton was the first model to become a fashion leader in her own right. The famous photograph of her at Melbourne Racecourse in December 1965, watching

Opposite Stiffened net picture hat worn by Jean Shrimpton. *Tatler*, 3 April 1963. Photograph by John French.

the Australian Gold Cup in a dress that ended three or four inches above her knees, was a defining moment in the much-contested history of the miniskirt. Whoever may have 'invented' it, it was this shot of Shrimpton, wearing a skirt that was shorter than any seen before, that made it fashionable – and the fact that the picture appeared in broadsheet newspapers was a new departure.

Other 'fashion moments' also made the broadsheets. The early coverage of Courrèges's 'Space Age' collection of Spring/Summer 1964 was the first to feature bare knees and a flash of thigh – encouraging comment and pictures in the news sections of many papers. In the summer of 1966, Cathy McGowan, television presenter, was refused entrance to the Dorchester wearing a saucer-hole trouser-suit, while the miniskirt had now reached such heights that an attendant had to be posted at the entrance to the Royal Enclosure at Ascot to bar those whose skirts threatened a breach of protocol. Fabrics new to everyday fashion – particularly if they had sexual connotations, as had leather and PVC – were featured on the news pages. So, too, was the invention and widespread marketing of throwaway

paper knickers in 1966, which were seen as somehow symptomatic of an increase in sexual promiscuity. Nudity, too, was newsworthy. The topless dresses and swimsuits designed by American Rudi Gernreich in the summer of 1964 went straight to the front pages, preceding the introduction of topless models in the tabloid press by five years.

Fashion was not only creating waves but had itself also become one of the ways in which it seemed possible to break down class barriers. Many key players on the 'scene', like the 'Terrible Three', were from working-class backgrounds. While Shrimpton was the daughter of a Berkshire farmer and thus solidly middle-class, 16-year-old Lesley Hornby, from suburban Neasden, worked as an apprentice in a hairdressing salon and lived with her parents in a council flat before her reincarnation as 'Twiggy'. Her much older boyfriend and mentor was an ex-barrow boy and boxer, Nigel Davies. Interestingly, while he christened her 'Twiggy' he reinvented himself as 'Justin de Villeneuve', proving that the breaking down of class boundaries might be an illusion that worked in both directions. He transformed her image by taking her to top hairdresser Leonard, who

Far left Celia Birtwell and Ossie Clark, dress. Paper (bonded fibre). British, 1967. Given by Zika Ascher. V&A: T.261–1988.

Left Jane Asher in a paper dress printed by Celia Birtwell. *Nova*, September 1966.

Opposite Courrèges stunned the Paris couture audiences in 1964 with short skirts and flat white boots. Photograph by John French, 1965.

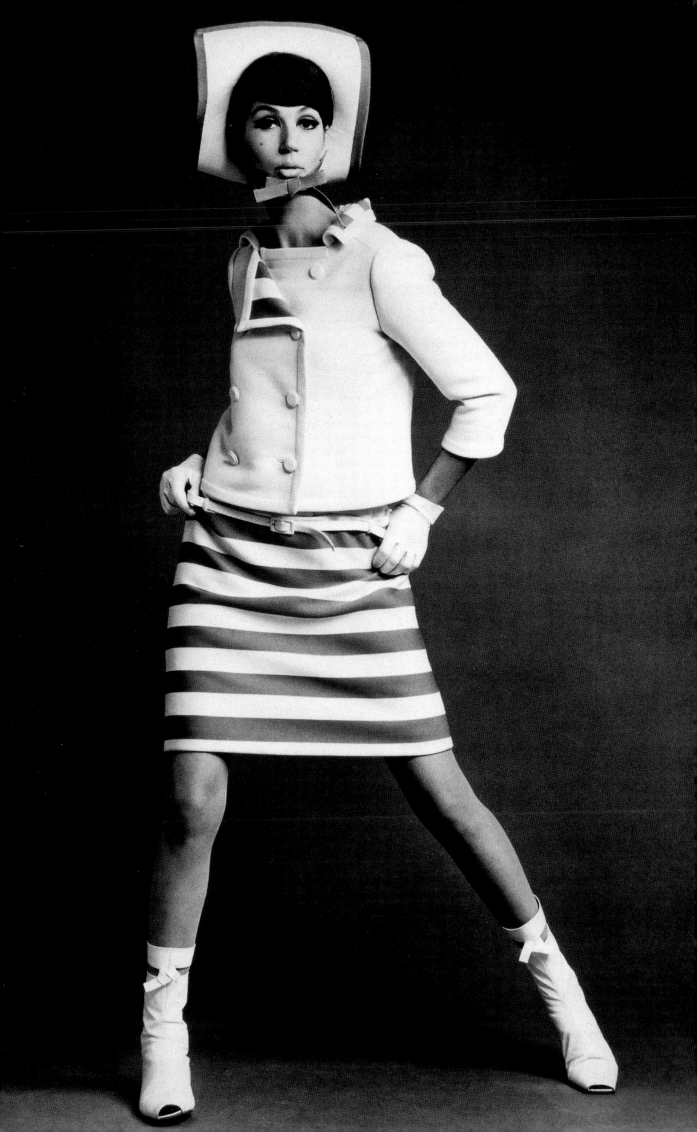

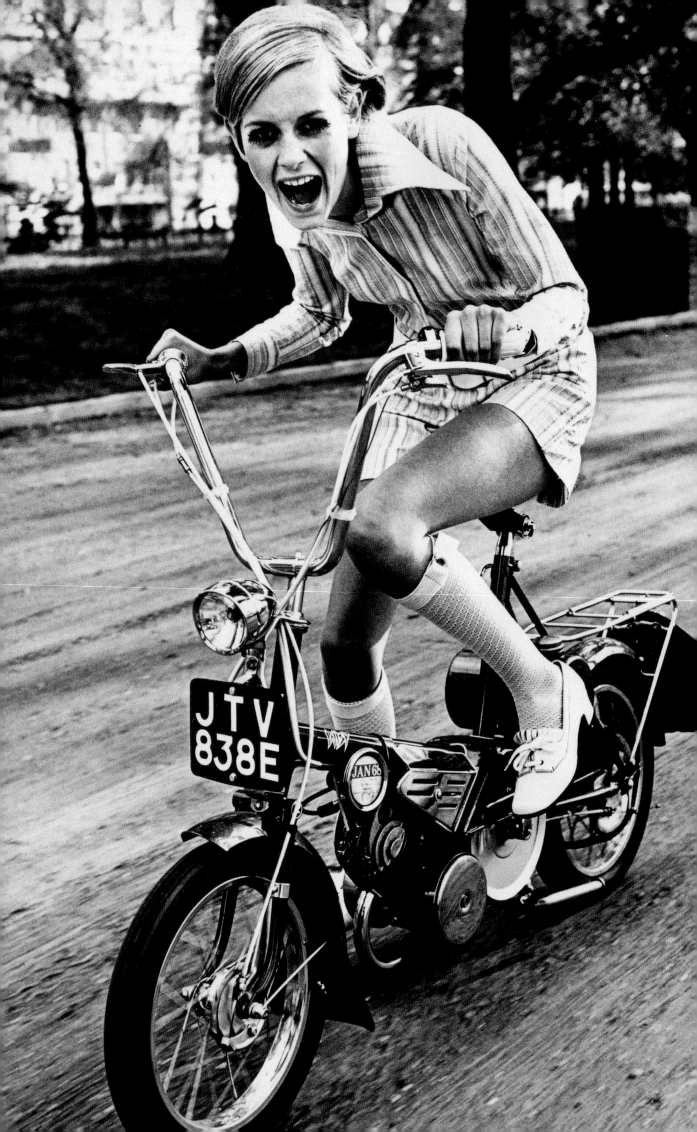

cut her long hair into the famous crop, and by teaching her to paint lashes underneath her eyes, like those on a Victorian doll he had once owned.[7] He persuaded Felicity Green of the *Daily Express* to see her and she instantly ran a feature, headlined 'Is this the Face of 66?' In those days, the fashion pages of the dailies had far more influence than they do now, and her career took off. Twiggy, seen everywhere in the media, was promoted in Europe, the United States and Japan and young female fans across the developed world cut their hair and painted on underlashes in imitation. Her androgynous body, childlike face and ingenuous manner perfectly suited the mood of the mid-1960s.

The new models were used, at first, in the existing magazines, which adapted their style to suit the changed mood and fresh, young look. Twiggy, in particular, was often photographed in movement – leaping across a room, for example – to emphasize her youth. One shot portrays her perching on a cupboard in a manner that could be reminiscent of *Alice in Wonderland*, while in another she is riding a scooter, with wide grin and bare knees, making her look like a schoolgirl playing

truant. Twiggy and the other models were joined, in the pages of *Vogue*, by more key figures from the London media landscape. Throughout the 1960s, *Vogue* ran a new column, 'People Are Talking About...' which covered new plays, films, and personalities, so that a flick through the magazine would show not only the latest clothes but also the latest faces on the 'scene'. These included rock stars, actors, boutique owners and television stars such as Peter Cook. In those days 'slender and very good-looking',[8] Cook was the most fashion-conscious of all those involved in the new wave of 'satire', which began on stage with *Beyond the Fringe*, moved to television with *That Was The Week That Was* and into print with *Private Eye*.[9]

The 1960s surely witnessed the 'coming of age' of the modern cult of celebrity. It was, after all, this decade that prompted Andy Warhol to state that in future everyone would be famous for 15 minutes. The 1960s saw, too, the emergence of the new phenomenon of the celebrity couple.[10] Paul McCartney's first girlfriend after the Beatles became famous was actress Jane Asher. Model Patti Boyd would later marry George Harrison and then elope

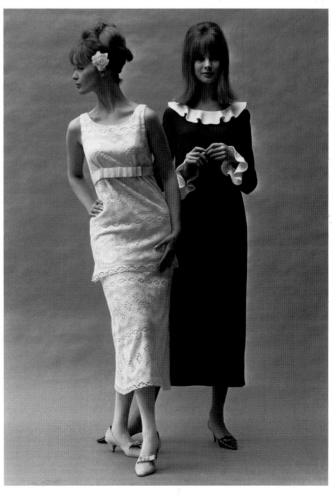

Opposite Twiggy photographed by Ronald Traeger, July 1967.

Above Twiggy in slip dress by Foale and Tuffin. *Vogue*, 1 October 1967. Photograph by Sir Cecil Beaton.

Right Long dresses by Mary Quant. Photograph by John French, 1964.

with Eric Clapton, inspiring the latter to write 'Layla', still his best-known song. Boyd became a favourite model of designer Ossie Clark, who adored her 'razor-sharp ankles'.[11]

On the December 1966 cover of *Petticoat*, Cathy McGowan, presenter of weekly pop music programme *Ready Steady Go*, first transmitted in 1963, handed out the New Year honours. This show was not only one of the most successful independent television programmes of the 1960s, it was also very important as a promoter of particular fashion trends. If McGowan wore a particular dress on Friday evening, when the show was transmitted, then it was a belief held by many working in the fashion industry that the same dress – or its look-alikes – could sell out in shops across the UK on the following afternoon. And for many young men this weekly programme, with its catchphrase 'The Weekend Starts Here', was also a vital source of information. Clothes-conscious boys had no fashion magazines of their own, although the small ads in the weekly music papers enabled them to purchase the right boots, jacket or shirt should they live outside London and be unable to reach Carnaby Street.

Somehow, the commercial possibilities of the show were thoroughly mined without it losing its all-important credibility with its young audience. McGowan was not the only figure designers and boutique owners sought to dress on-screen. There was a new crop of young, fashion-conscious British singers such as Lulu, Cilla Black, Dusty Springfield, Marianne Faithfull and the famously barefooted Sandie Shaw. Shaw looked like a model and married Jeff Banks, designer and owner of the new boutique Clobber. The BBC had enjoyed respectable viewing figures for its 'youth programmes' in the previous decade, notably *6.5 Special*, but *Ready Steady Go* swept aside all competition. The BBC fought back in 1964 with the launch of *Top of the Pops*. This programme succeeded because it copied the format of *Ready Steady Go*, whose producers had pioneered the transmission of a live show, with performers 'singing' (miming as their record was played), while a studio audience – carefully selected from the hundreds who queued in advance – danced. These programmes also showed those who lived outside the big cities with their new clubs what the latest dances were, and how to do them.

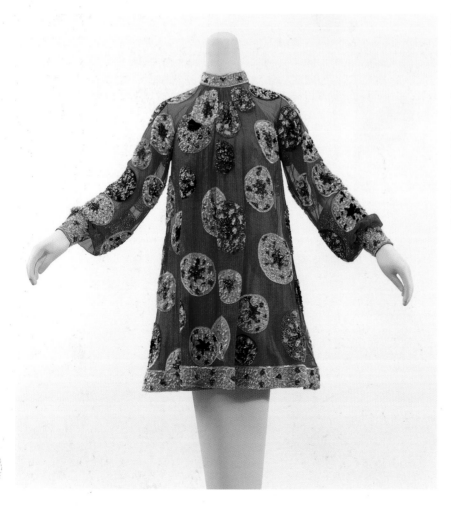

Radio was also transformed in the 1960s. Illegal offshore 'pirate' stations such as Radio Caroline, which began transmission in 1963, provided young people with the non-stop music programmes they wanted – and the BBC was soon forced to reconfigure itself. The BBC Light Programme became 'Radio One' and successfully lured DJs including Tony Blackburn and later John Peel away from the pirate stations, which were outlawed by new legislation in 1967.

Cinema lost its position as image-maker supreme and music became the main driving-force in fashion. Whether it was Beatle jackets and haircuts, the long hair and scruffy clothes of the Rolling Stones, the demure dresses worn by McGowan or the more exotic clothes that came later on, when Keith Richards, Anita Pallenberg and Jimi Hendrix seemed to have raided a well-stocked dressing-up box, there was throughout the decade a sense of rapid change, of something new to watch and to emulate. Record album covers reflected the new style-consciousness of British music – from the moody, noir-ish photographs of the early 1960s through the quirky graphics of *Revolver* (1966) to the famous 'pop' collage that artist

Peter Blake created for the cover of *Sergeant Pepper's Lonely Hearts Club Band* (1967).

The cast of Swinging London as portrayed in the British media was rather more wide-ranging than in *Time*'s article. The British version consisted of musicians and their friends, a few brand-new British film stars (Julie Christie, Michael Caine and Terence Stamp), the occasional charismatic painter or persistent gallery owner, minor aristocrats and a flotilla of hangers-on. Although for many reasons the Beatles were the most important band of the 1960s, the Rolling Stones, edgy and seemingly more dangerous, were often more newsworthy. They were arrested in 1962 for urinating on a garage wall, producing the apocryphal headline 'Would you let your daughter marry a Rolling Stone?', while the famous Redlands 'drug bust' of 1967, and the subsequent trial of Mick Jagger and Keith Richards, made Marianne Faithfull forever 'the naked girl in the fur rug' of the police reports. Finally, Brian Jones's mysterious death-by-drowning in 1969 was seen by many as yet one more indication of a changed moral climate.

(handwritten note in margin: Talk about / Blow up / also)

Although cinema might have lost its leading role as a fashion influence, it could still provide stars who interested the media. The northern actors of the British New Wave such as Albert Finney and Tom Courtenay were joined by Cockney boys Caine and Stamp, while Julie Christie seemed to be the very incarnation of the King's Road girl. When she made her mark in *Billy Liar* (1963) she became 'Honeygirl of the Month' while *Petticoat* enthused endlessly about her spontaneity and friendly manner. The films themselves, however, did their best to undermine any illusions about 'Swinging London'. Rita Tushingham in *The Knack* (1963) played a provincial girl who comes to London in search of the 'scene' she has read about – a copy of *Honey* is in shot as her train nears London – and she is swiftly disillusioned.[12] The heroine of *Georgy Girl* (1966) is a plain, dowdily dressed music teacher (Lynn Redgrave). It is the flinty-hearted semi-villainess, played by Charlotte Rampling, who is the epitome of the metropolitan 'dolly', dressed for the part by Foale and Tuffin. Christie, meanwhile, the most enduring icon of 1960s British film, was cast as the spoilt, deceitful fashion model in *Darling* (1964).[13] This film showed the industry and its magazines in a negative light – the players

shallow, the readers gullible. *Kaleidoscope* (1966), a rather feeble film, starred Susannah York as a boutique owner and fashion designer. Once again, the scene-setting clothes were provided by Foale and Tuffin.

The most interesting cinematic depiction of 1960s London was perhaps Antonioni's *Blow-Up* (1966). David Hemmings played a fashion photographer overtly modelled on David Bailey, while models Verushka and Peggy Moffitt appeared as themselves.[14] Hemmings scorns the fashion shoots that have made him rich, but his adventures outside the industry leave him even more disillusioned and frustrated. Lastly, the film *Performance*, made in 1969 and released in 1970, which starred Jagger as a reclusive, washed-up, drug-dependent rock star, was interpreted by many critics as an epitaph for the decade. It also showed quite graphically the nastier side of the 1960s flirtation with the glamour of the criminal underworld, which had briefly made of the psychotic Kray brothers two very unlikely pin-up boys.[15]

If feature films showed the fashionable metropolis as a deceptive mirage, where

Opposite Jean Shrimpton and Terence Stamp, 1964. Photograph by Terry O'Neill.

sybaritic excess was invariably punished, television's most famous drama *Cathy Come Home* (1966) showed London in even grimmer terms. Its harrowing ending, where the homeless young heroine screams helplessly as her children are taken into care, led to the formation of the charities Crisis and Shelter. Television, however, was equally happy to screen fashionable fantasy. *The Avengers*, which ran from 1962 to 1969, was successful as tongue-in-cheek drama and as fashion statement. Its heroines, Honor Blackman and Diana Rigg, wore catsuits of black leather, long flat-heeled jackboots and short, pointed dominatrix boots, plus a range of minidresses and outfits designed by John Bates. The screen garments were linked to high-street retailing, while the hero of the series, actor Patrick Macnee, recorded the popular duet 'Kinky Boots' with Blackman in 1963.[16] Macnee's character, John Steed, combined the bowler hat and furled umbrella of the city gent with narrow jackets and trousers created for the series by Pierre Cardin.

The 1960s was the first and perhaps the only decade where London was for a short time perceived by many as chief amongst fashion capitals, prime dictator of style and taste. But the *Time* issue that christened and celebrated this moment formed a high-water mark. It came just over halfway through the decade – and the London it described was already beginning to lose its potency. The following year would see the invention of a new media tag, the 'Summer of Love', which began with flowers and ended with fighting in the streets. From 1967 onwards, the West Coast of America provided the new bands, the new looks – and the new politics. San Francisco became the epicentre of youth culture and India the subject of a new interest in mysticism. For others radical activism was now more important than anything else, certainly more important than 'trivial' issues of style. In May 1968, students and trade unionists combined forces and brought Paris to a standstill that lasted several weeks. This was followed by student occupations and demonstrations across Europe and the United States.

The media found all of this confusing at first – but soon came up with lazy labels such as 'flower power', as if all the things that happened in the last years of this decade could be explained away with journalistic

facility. In reality, the late 1960s was infinitely more complex.[17] By 1966, the civil rights movement in the US had given birth to a new militancy, and the longstanding awareness of the threat of nuclear war was replaced by real anger about the escalation of the Vietnam War. Meanwhile a bohemian subculture of many years standing began to take on the size – and, significantly, the contradictions – of a mass counterculture.[18] And as the decade changed tack, so once again there were changes to the London media's mode of operation and relationship to fashion culture. Following the American lead, there was a rash of 'alternative' publications and the underground press flourished. Its products can perhaps be separated into two strands. The first comprised subversive and strangely apolitical papers, such as the *International Times* (1966) with its masthead featuring Theda Bara, 'It-Girl' of the 1920s, and *Oz* (1967), comic-book in format and sexually controversial in content. The other strand was explicitly political, usually Marxist, and included papers such as *Black Dwarf* (1968) and *Red Mole* (1969). These would be followed in the early 1970s by the feminist *Spare Rib* (1971) and *Gay News* (1972). Now demands for

'liberation' found a new focus, but the attitude of such titles to fashionable consumer culture was generally ambivalent at best.

Within mainstream journalism, there were different responses to social change. The most significant was the new women's monthly, *Nova*, which appeared in 1965 and moved swiftly into new terrain. Provocative articles examined racial discrimination, sexual politics and dysfunctional families as the decade drew to its troubled close. Its art direction and layout, too, were unlike that of any other magazine, and its fashion editor, Molly Parkin, together with stylist Caroline Baker, regularly devised clever, humorous and sometimes thought-provoking fashion spreads. But *Nova* did not last for long; the 1970s brought the slick *Cosmopolitan*, edited by the Manhattan maven, Helen Gurley Brown, to a country now bewildered by economic collapse, growing unemployment and widespread discontent.

In the decades that followed, the media that had created and valorized the 1960s now trivialized it by constantly harking back to, and reinventing, the mythology of Swinging

Right *Men in Vogue*, November 1965, featuring actor James Fox.

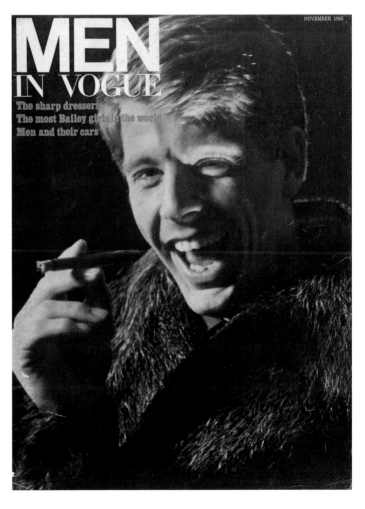

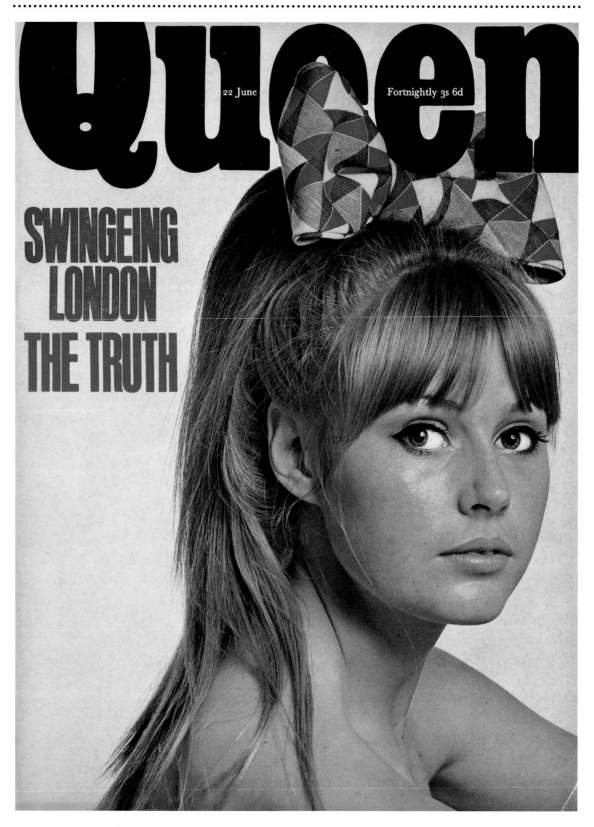

Queen

22 June Fortnightly 3s 6d

SWINGEING LONDON THE TRUTH

Above 'Swingeing London', *Queen*, 22 June 1966. Jocelyn Stevens' trademark irreverence is displayed two months after *Time* magazine's article.

London. But the media also helped to foster a competing myth – that of the 'Permissive Society' which, it was claimed, was responsible for every social ill, from over-liberal parenting to vandalized bus shelters and violent video games. Margaret Thatcher, of course, was perhaps the most famous exponent of this argument, declaring in 1982 that we 'are reaping what was sown in the sixties. The fashionable theories and permissive claptrap set the scene for a society in which the old virtues of discipline and self-restraint were denigrated.'[19] Norman Tebbit, as Conservative Party chairman, took up this idea with enthusiasm in an abrasive speech made in 1985, which attacked 'the era of post-war funk which gave birth to the "Permissive Society"... [and] in turn generated today's violent society.'[20] This new, negative mythology now competes with romanticized notions of 'liberation' and the perception of the era as an endless party. No one would deny that these 10 years produced the decriminalization of homosexuality and saw significant moves towards sexual equality and the outlawing of racial discrimination, yet both mythologies tend to ignore these facts. They both seek to play down the political awareness generated by the period, surely a more significant legacy than short skirts, sexual licence and the widespread popularity of recreational drugs.

Cover Appeal

Magazine covers act as a commentary on the irreversible changes that affected British society in the 1960s. Established magazines such as *Vogue* had to adapt in order to survive. New, younger models replaced the elegant women who had stared out from its covers in the 1950s. David Bailey, Terence Donovan and Brian Duffy joined John French and Cecil Beaton as photographers of choice. The clothes shown were young in spirit, often the creations of the new designers increasingly featured inside the magazine. The models' make-up was a high-fashion version of that seen on many young metropolitan girls: pale and interesting, in contrast to the mask-like red lipstick, coiffed hair and plucked eyebrows of former *Vogue* cover stars. Each new phenomenon was reflected here – whether Twiggy-inspired underlashes or psychedelic face painting. *Vogue*'s competitor *Queen* took this approach further in targeting a more diverse audience and showcasing contemporary style. The *Queen* cover for July 1966 used the distinctive American model Peggy Moffitt, whose elaborate eye make-up was an art form in itself. She had already found fame modelling Rudi Gernreich's sensational topless swimsuits of 1964.

Under the leadership of fashion editor Molly Parkin, *Nova* was even more innovative in both style and content. One spread showed Jane Asher, actress and Beatle girlfriend, in a paper dress printed by Celia Birtwell, who worked with and was married to designer Ossie Clark (see p.88). Where other young designers looked forward, Clark and Birtwell looked back – to a more romantic era or to old-fashioned glamour. Where other dresses skimmed the body, Clark's clothes emphasized the curves beneath. It was typical of *Nova* to promote fashions that challenged dominant trends. As art director Harri Peccinotti commented, their fashion pages 'were almost an insult to fashion at times'. Other *Nova* covers and spreads showed the darker mood of the late 1960s, encapsulated so effectively in the photography of contributors such as Sarah Moon. No women's magazines before had covered this ground, or adopted such arresting visual strategies.

Petticoat was targeted firmly at younger girls, and had a clear idea of their interests and purchasing power. Its original strapline, 'for the young and fancy free' was changed in 1967 to 'The New Young Woman.' Even *Petticoat* readers could not remain entirely 'fancy free' as the cultural climate around them changed. In December 1966, Cathy McGowan, the presenter of *Ready Steady Go*, is depicted advising Harold Wilson about the real 'New Year Honours'. To have put the Prime Minister on the cover of a teen magazine was another first – and to do so tongue-in-cheek gives some clue as to the guiding anti-establishment spirit behind the title. Contemporary staffers Janet Street-Porter and Lynne Franks had little respect for traditional authority – and paradoxically, this guaranteed for both women the trappings of conventional success in their future careers.

Left 'I have taken the pill'. *Nova*, September 1968.

NOVA

SEPTEMBER 1968 THREE SHILLINGS AND SIXPENCE

I have taken the pill. I have hoisted my skirts to my thighs, dropped them to my ankles, rebelled at university, abused the American Embassy, lived with two men, married one, earned my keep, kept my identity and, frankly... I'm lost

Find yourself on page 38.

Exclusive: God's diaries

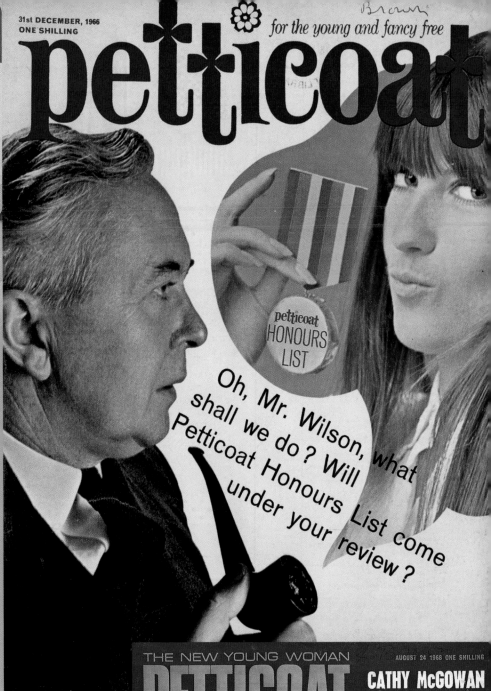

Above Peggy Moffitt, *Queen*, 20 July 1966.

Below *Petticoat*, December 1966.

Right *Petticoat*, December 1966.

Below right *Petticoat*, 24 August 1968.

Oh, Mr. Wilson, what shall we do? Will *Petticoat* Honours List come under your review?

Out of London

DAVID GILBERT

On 7 February 1964, at 1.35pm local time, the Beatles landed at Kennedy Airport to begin their first tour of the USA. Ten thousand screaming fans were waiting for the group. These teenagers had been attracted by much more than just the music of the Beatles. Beatlemania was as much about a new look (and a new kind of sex appeal) as it was about a new sound. It is hard now to appreciate the shock-value of the early clean-cut Beatles who landed at JFK. One American Beatles fan remembered: 'walking down the street with two of my friends and discussing them. We all said how ugly they looked in their photographs, especially with no collars on their jackets … Then slowly we changed our minds … At the beginning I loved Paul most of all. He was so beautiful.'[1]

The Beatles' arrival in the United States marked the start of the so-called 'British invasion' of popular music and fashion styles. By the time of *Time*'s 'Swinging London' edition in 1966, something that was identifiable as a British or particularly as a London look was already well known internationally. However, the example of the Beatles shows how difficult

it was to define precisely what that London look consisted of. The collarless suits with piped detailing that had at first seemed so ugly to New Hampshire ninth-graders had been run up by the London show-business tailor Dougie Millings in Old Compton Street.[2] These were, however, unashamed copies of the new 'cylinder' line suits introduced by Pierre Cardin in his first Paris menswear collection of 1960. Cardin was to pioneer a new fashion order of designer labelling, giving ready-to-wear clothes not just a distinctive cut and line, but also endowing them with the mark of a designer's signature.[3] But even Cardin struggled to retain identification with what was to become known to millions simply as the 'Beatle jacket' – and regarded as a London rather than a Paris fashion. By the time they arrived in America the Beatles had moved onto another new style, involving another fashion borrowing by Dougie Millings. The Beatles' follow-up look reinstated suit collars, but in velvet.[4] These suits belonged to an Italian idiom that had been naturalized as popular fashion in London from the mid-1950s onwards, in the shops of Cecil Gee, John Michael and Millings himself. In the

Above The Beatles pose in new suits with an American flag in a Paris photo studio prior to their first visit to the United States in January 1964. © EMPICS/AP.

Above Pierre Cardin collarless suits from the 'cylinder-look' of 1960. These were to become the model for Dougie Millings' Beatle suits. © Keystone.

Mod-culture of early 1960s Britain, the designation of cut, line or detail as 'Italian' or 'French', 'Roman' or 'Parisian' was vital in a grammar of style that marked out the fashion sophisticates and true group insiders. However, when popularized and exported to America by the Beatles (never a Mod group proper), these fashions signified simply 'London', just as the term 'Mod' lost its particular meaning crossing the North Atlantic, becoming a catch-all for all that was 'modern' about English popular culture.[5]

London's new position in the geography of world fashion centres worked through this mixture of innovation, borrowing and popularization. *Time* suggested a kind of fashion cycle of cities in which it was now London's turn after 'thrusting New York' in the 'shell-shocked 1940s', and the 'easy Rome of *La Dolce Vita*'. However, London did not become the single central point where fashions originated and were then broadcast to a waiting world. Although the 1960s was a period of near-terminal crisis for the Paris couture system, London did not replace it as the centre of fashion's world order, nor indeed did any other fashion capital. Instead

the whole geometry of fashion changed. This transformation arose from economic, social and cultural changes that were widespread in North America, Western Europe and Australasia. Increasing consumer affluence, particularly among teenagers and young adults, changing relations between the generations, and new attitudes towards popular culture, leisure and the body, together with innovations in materials and manufacturing techniques, formed the basis for a revolution in the way that the fashion system worked. But while these changes were diffused across the Western World, changes in fashion became closely associated with certain key sites, particularly London, and then slightly later, America's West Coast. In these places the connections between fashion and the emerging music influence were very strong, and they were marked by popular style cultures that both influenced and drew upon the work of local designers.

Other major fashion centres had to respond to the times. In Paris a new generation of designers stretched the couture system to breaking-point. It is hard to judge how much this was influenced directly by what was going

on across the Channel. For example, both Cardin and Mary Quant claimed to have 'invented' the miniskirt in the late 1950s. What is more important, however, is that the experiments that exposed new areas of the female body in daywear provoked a reaction and found a market in two very different fashion cities. In the early 1960s, Cardin, André Courrèges and Yves Saint Laurent broke away from the traditions of restraint associated with the main couture houses. Although Paul Poiret and Elsa Schiaparelli had caused outrage with their avant-garde experiments in couture fashion earlier in the century, this new generation of designers drew upon art and particularly popular culture in ways that were unprecedented in Paris. In 1965, Saint Laurent's Autumn/Winter collection quoted from the work of the Dutch De Stijl artist Piet Mondrian, using the artist's trademark grids of thick black lines and blocks of colour on a simple short tubular shift. While still operating in the elite circles of Parisian fashion, the Mondrian collection transformed abstract modernism into an open acknowledgement of the emergence of pop sensibilities and new codes of feminine beauty and display.[6]

Cardin, Courrèges, Emanuel Ungaro and Paco Rabanne experimented with futuristic 'space-age' looks in the mid-1960s that featured new shapes and used new technologies. Cardin's 'Cosmos' outfits of the period were inspired by the first space-walks, and used vinyl, plastics and large zips, alongside more traditional fabrics. The headgear of vizored caps or felt helmets was the most striking feature of the Cosmos collections, but they perhaps had more lasting significance in the promotion of unisex fashions.[7] The combination of body-fitting sweater, under a tunic or fitted pinafore dress, with dark tights or straight trousers, created a distinctive shape that was widely copied and adapted – although in Britain the popular appeal of the Cosmos look was probably limited by the unofficial adoption of Cardin as the house style for the TV puppet series *Thunderbirds*. Paco Rabanne drew upon his training in architecture and his experience in jewellery design to push fashion technology still further. Rabanne created sculptural dresses made from plastic disks and metal chains that often required pliers rather than needle and thread in their construction. This radical experimentation with materials was an increasingly widespread feature of elite fashion design in the mid-1960s. In the United States,

Left Pierre Cardin, 'Cosmos' outfit. Wool jersey. French, 1967. Given by M. Pierre Cardin. V&A: T.75-F–1974.

Above and opposite Paco Rabanne, dress. Plastic and metal. French, 1967. Worn and given by Baroness Helen Bachofen von Echt. V&A: T.165–1983.

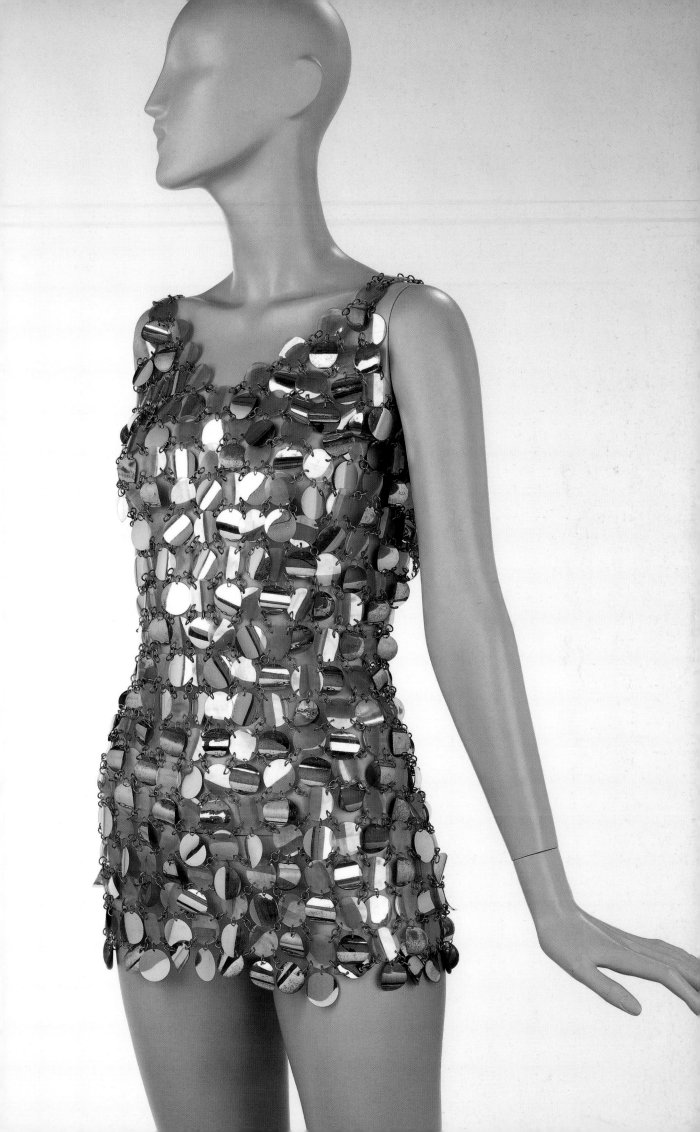

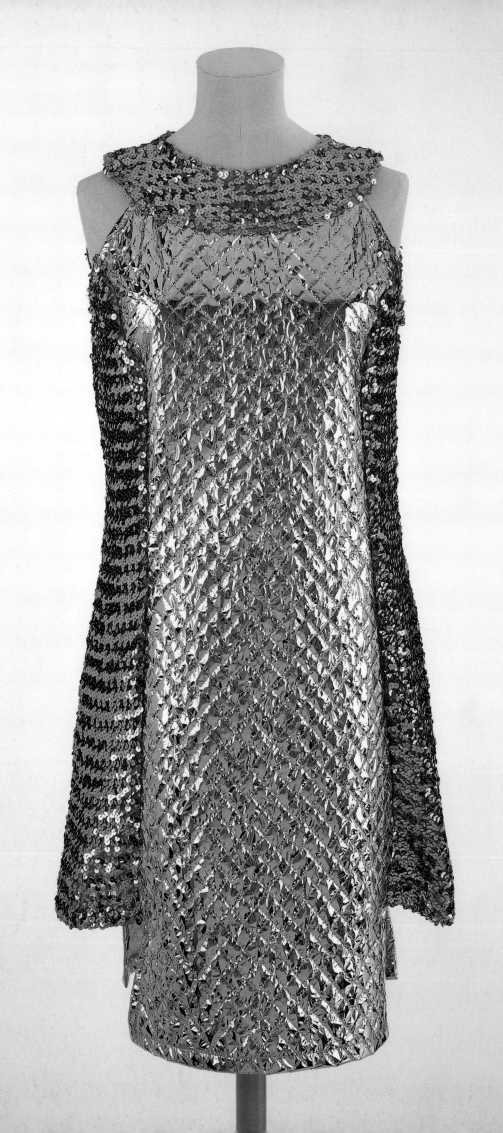

Rudi Gernreich used transparent vinyl panels in his dresses, while Diana Drew created an outfit incorporating small electric lights (the line only partly spoilt by the battery box).[8] Leonard Joseph's dress designed in 1965 for the New York Forward Look boutique is another good example of such elite experimentation. This glittering gold cellophane and sequinned shift was worn on the New York party scene by Princess Lee Radziwill, the international socialite, famous mainly for being the younger sister of Jackie Kennedy Onassis.

The influence of London fashion on these wider developments worked in a number of ways. First, the model of London as an alternative urban fashion culture was an important part of the pressure on the established system. In the early 1960s, fashion culture in Paris was becoming more like that in London, and there was often explicit reference to English developments. For example, in men's wear, the 'minet' look, pioneered by the tailor and manufacturer Simon Cressy at his store Renoma in the 16th arrondisement, drew heavily on English-style narrow-shouldered, tight-fitting suits. The rue de la Pompe in the 16th became a kind of Parisian Carnaby Street,

cultivating a 'Frenglish' style characterized by mohair suits, Harris tweeds or blazers.[9] While the minet style often consisted of English classics refracted through the influence of American Preppie or Ivy League style (what became known as the 'Kennedy look' in France), the emergent shopping environment was a much more direct emulation of the London scene, with boutiques with anglicized names, such as Mayfair, Twenty, Harrison, and most bluntly Carnaby Street. (The Parisians' expertise in English style, however, was rather more advanced than their geographical knowledge, as one off-shoot of the Renoma boutique ended up with the name Cardiff.[10]) This influence was also felt in 1960s New York, where the London scene provided the model for new boutiques. Paraphernalia, the most influential of the new New York boutiques, opened on Madison Avenue in 1965. The founder Paul Young, instrumental in bringing Mary Quant's clothes to a mass market in the US, saw his boutique as an overt challenge to the fixation with Paris that characterized the work of many New York designers. It was no coincidence that Paraphernalia's first collection was a 'London look' of shift dresses over checked sweaters and tights.[11]

Opposite Leonard Joseph for Forward Look, dress. Gold paper and sequins. American, 1965. Given by Princess Slanislaus Radziwill. V&A: T.297–1974.

If the development of London-style boutiques with new marketing practices and consumption cultures disturbed the established order within Paris, other aspects of the new London fashion scene helped to undermine the position of Paris in fashion's world order. Although British designers became more prominent, and the British fashion industry enjoyed a boom in international sales in the early 1960s, this was more about the symbolic significance of the new London than direct competition. The Parisian couture system relied on more than the production of a few hand-made dresses for the aristocracy or super-rich. The sale of patterns to foreign ready-to-wear companies (illegal in France itself) underpinned the mythology of Paris as the authoritative source of fashion edicts. This system reached a high point in the post-war accommodation between the French and American fashion industries that was aggressively promoted in American *Vogue*. The period after Christian Dior's 'New Look' of 1947 was marked by an unprecedented penetration of Parisian designs and influences into the American market. At the top end these were officially licensed copies, but the rapidly expanding American middle market was dominated by copies of the season's Parisian

looks, facilitated by the more liberal laws on style copyright in the US.[12] As the Broadway musical *Sweet Charity* put it, what many American women wanted was a 'copy of a copy of a copy of Dior'. As the designs were copied and recopied, making their way down the social hierarchy, the patina of Parisian design became thinner and thinner, but what was important was that there was still some lingering connection to the authentic original in the Paris collections.

The new sensibilities coming out of London showed that cutting-edge fashion could be different. The rise of Mary Quant – from joint proprietor of a rather chaotic and amateurish boutique on the King's Road to major international fashion influence – is indicative of the London effect. While in Bazaar's early years most of Quant's clothes went to a rather elite Chelsea set, what she achieved was a kind of symbolic democratization of fashion that was then exported to a wider world. Quant's claims for the classlessness of her looks could be naïve, but she played a leading role in shifting the focus of fashion towards a new kind of figure. In place of the wealthy, elite and

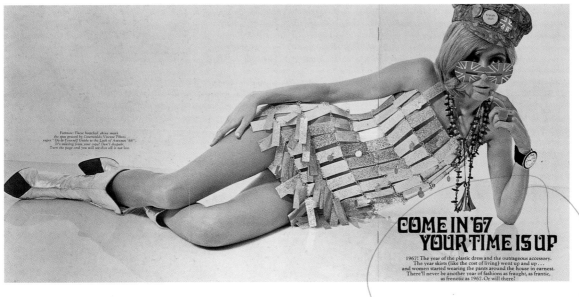

Above 'Come in 67 Your Time is Up.' *Drapers' Record.* 6 January 1968.

mature couture customer, Quant promoted the Chelsea Girl, a figure defined by her youth (and her skinny body shape), her casual, seemingly spontaneous, confidence in the city, and her willingness to experiment with a rapid succession of new looks. Mixing metaphors magnificently, Quant acknowledged that she had happened to start out when 'something in the air was coming to the boil', recognizing the way that this new fashion type tapped into social changes and new markets that were international in scope: 'Chelsea ceased to be a small part of London; it became international; its name interpreted a way of living and dressing far more than a geographical area.'[13]

This new form of fashion, unashamedly ready-to-wear, relatively affordable, and targeted at an international youth market, was also increasingly disposable and replicable. Quant (together with her business team of husband, Alexander Plunket Greene, and manager Archie McNair) was particularly astute in the licensing deals she made in the States, but in general it was hard to control the local and international spread of these looks. If the point was to 'knock it out because people aren't going to wear it very long',

the temptation for others to cash in with cheap copies of cheaply made originals was irresistible.[14] Sixties London saw a new intensity of copying that often undermined the position of elite design. Garments such as the Saint Laurent Mondrian dresses became simply another look to be 'knocked out' as cheaply as possible in the latest cut-price fabrics, Bri-Nylon included. If, with hindsight, this was just a staging-post on a road that was to lead to the 'fast-fashion' of multi-national firms, off-shore production and planned rapid turnovers in style, at the time it seemed to mark a new kind of fashion order that was less controlled and hierarchical, and more sensitive to the demands of actively creative consumers. Tellingly, both Quant and Cardin recognized very early that the way for the designer to make money in these new conditions was through the branding of mass-produced clothing. Perhaps one of the most prescient events in the fashion history of 1960s London was the appearance of a Cardin diffusion range at the opening of Miss Selfridge, the first of a new wave of 'boutique' chain-stores.

The late 1950s and early 1960s were a buoyant time for the British rag trade. The

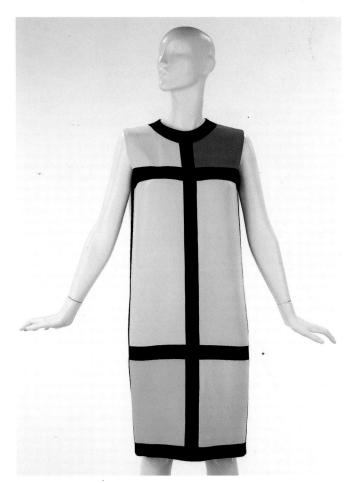

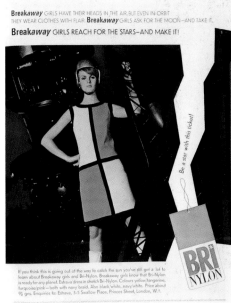

Left Yves Saint Laurent, dress. Silk crepe. French, 1965. Given by M. Yves Saint Laurent. V&A: T.369–1974.

Above Bri-Nylon Mondrian style dress advertised in British *Vogue*, March 1966, p.159.

volume of fashion exports roughly doubled between 1954 and 1963, then doubled again by 1965, with a total value that year of £50 million.[15] This increase was in part the success of individuals such as Quant, but also reflected a wider restructuring in the industry's supply chains and publicity networks. In 1954 the Fashion House Group of London was founded, which aimed to promote British designers internationally through London Fashion Weeks (from 1958) and other events. By the mid-1960s, the Fashion House was increasingly caught up in the kind of promotional activities that were developing in the music industry. In 1966, in an echo of Beatlemania, the latest London designs were shipped across the Atlantic. As Moss Murray, chairman of the Fashion House, remembered: 'we sailed on the *Queen Elizabeth* with a party of eighteen model girls, manufacturers and twelve top British journalists. We were a wow! It simply wasn't done for a big store not to have British fashions.'[16]

The international marketing of Swinging London worked in other ways. The spectacle of fashion had long been part of the way that Paris was promoted as a tourist destination.

In the post-war period, guidebooks for American visitors to the French capital routinely included itineraries around the main fashion houses. Swinging London worked differently. Here the invitation to the tourist, and particularly to an emerging generation of young travellers, was to become part of the scene, rather than to observe the sacred shrines of high fashion. Unlike the music scene, which tended to be nocturnal and episodic, and dependent on who was playing where, fashion culture provided the most visible and reliable tourist spectacle of the new London.[17] Entrepreneurs such as John Stephen recognized this well before *Time*'s Swinging London edition, producing T-shirts, novelty hats and badges that actively commodified Carnaby Street as a tourist experience.

The fame of the *Time* edition has also obscured the degree to which the idea of Swinging London was an international media event, to some extent driven by the canny publicity of key players in the London fashion world, but increasingly with a momentum all of its own. The *Time* edition was just one part of the media frenzy of 1966 that brought widespread

Far left Ties in Carnaby Street as pictured in *Triunfo* magazine, November 1966. Pictures by Gigi Corbetta. V&A: AAD/1998/5/16.

Left The London 'Mod' fashion as seen from Germany. *Bravo* magazine, 1966. V&A: AAD/1998/5/16.

Above *Carnaby News*
– selling Swinging London
in Amsterdam, September
1966.

international coverage of the new London. As well as many short fashion features on the London look, there were more substantial commentaries and photo-essays on London in *Die Zeit* (Germany, March 1966), *Sogno* (Italy, June 1966), *Oggi Illustrato* (Italy, August 1966), *Réalités* (France, October 1966), *Triunfo* (Spain, November 1966), and *Zie* (Netherlands, January 1967). *De Spiegel* (Netherlands, July 1966) ran a special feature on 'Londen' that even included an alternative map of the city, more explicitly youthful than the *Time* version, focusing on Carnaby Street and the clubs and discotheques of Soho.[18] John Stephen was smart enough to recognize that the promotion of the London scene depended on more than the mainstream press. By 1966, Carnaby Street was increasingly regarded as a tourist trap and past its best, both by the fashion press and particularly by those who had been the Mod 'faces' at the cutting-edge of earlier fashions. Stephen turned to young Europeans, trying to prolong the image of the street as the world centre of youth culture. *Carnaby News* was an early attempt at stealth marketing, freely distributed from several new London-style boutiques in Amsterdam, and designed to look like an independent fanzine.

Although Carnaby Street was indeed long spent as a force on British fashion by the end of the 1960s, and declined still further in succeeding decades to be dominated by cheap jeans and cheaper tourist tat, the myth-making of 1960s had permanently altered tourist geographies of the city. The rediscovery of Carnaby Street in the 1990s by multinational trainer and other 'streetwear' companies owes much to the lasting power and commercial value of the clichés that were encoded in guides and tours of the city.

Fashion took other routes out from London. The emergence of a national media, particularly new television programmes and magazines aimed at a youth audience, meant that knowledge of new fashions spread much more rapidly than before in Britain. Demand for these looks was met in part through mail order. Biba began in 1963 as the Biba Postal Boutique, one small example of what became a major innovation in retailing.[19] Mail order itself was not new, but the proliferation of publications, particularly the new music and fashion press, meant that youth fashions could be carefully niche-marketed. The small ads of the *New Musical Express* or *Melody Maker*

Above Cinderella wears a pattern-made dress to the ball. *Nova*, July 1966, p.48.

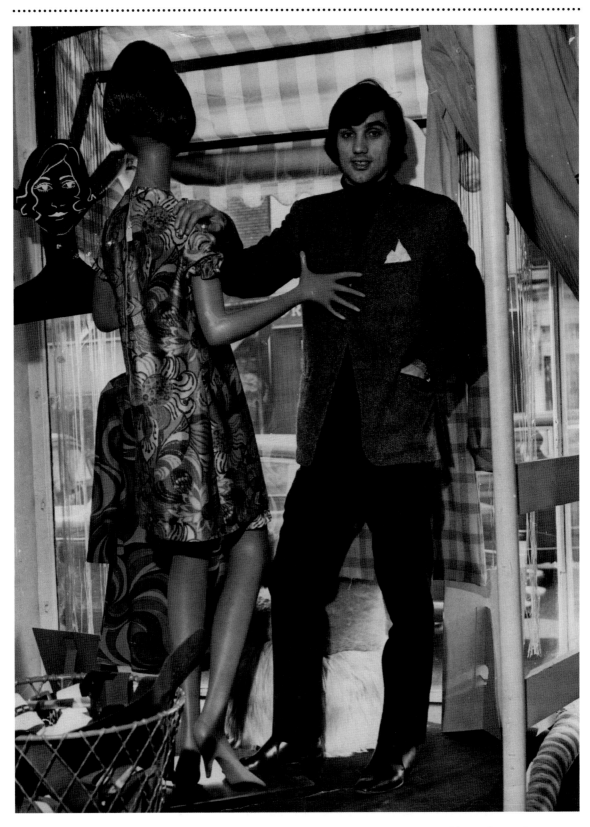

Above George Best poses with a mannequin in the window of his boutique, situated not far from Manchester United's Old Trafford football ground, 1966. © Getty Images.

became a printed version of Carnaby Street or the King's Road, supplying versions of the London look to Reading or Redditch. The 1960s were also the last great age of home-dressmaking in Britain. Designers such as Quant and Gerald McCann produced pattern designs, with one Quant for the Butterick company selling 70,000 copies.[20] Even magazines such as *Nova* promoted home-made dresses as the way that 'Cinderella could get to the ball' without spending a fortune. Both mail order and home-dressmaking worked as the vicarious consumption of a piece of metropolitan style. One of the features of the 1960s was the extent to which a relatively circumscribed London scene rapidly entered national mythologies, and how many people wanted some material connection to it.

Time simplified the geography of Swinging Britain to an outline map with a large arrow pointing south to London. *Time*'s arrow matched the stereotypes found in such films as John Schlesinger's *Billy Liar* (1963) that contrasted the greyness of the north with the excitement of the metropolis, but both underplayed the significance of other cities in the development of new youth subcultures. Nottingham in particular saw the development of a strong boutique culture that for a time in the mid-1960s sustained an independent design culture, including Paul Smith's Birdcage. Elsewhere the boutique could be rather more derivative, as footballers and other new celebrities climbed aboard the bandwagon. But one-off stores owned by individuals were disappearing in London and other cities by the end of the decade. John Stephen, for example, moved the focus of his business away from Carnaby Street to concentrate on a national chain of rather more conventional menswear stores. Nonetheless, there were some who still strove to keep the flame alive. The *Drapers' Record* reported on the Top Gear Motique, a psychedelic caravan, owned by Mr Marcus Weiner, a former cigarette salesman.[21] The Motique's mission was to take the latest gear to the style-deficient citizenry of East Anglia. Perhaps this was one journey too far out of London, as the Motique was last spotted in a field outside Ipswich.

London on Tour

The 1960s saw the emergence of designers and fashion entrepreneurs as modern celebrities. Fashion designers had been famous before, but the key figures of the 1960s rapidly learnt to use the new culture of fame pioneered in the music industry. The great specialists at this tactic were Mary Quant and John Stephen. Quant toured the States shortly after the Beatles' first tour, and was at first surprised to be asked to do interviews on pop music stations about the whole British scene, not just her fashions. She learnt quickly, and later expeditions abroad were organized very like pop or rock roadshows. She sometimes formed a double-bill with the self-styled 'King of Carnaby Street', and in 1966, Stephen and Quant took their 'Mode-Show' to Europe, teaming up with local English-style bands such as the Swedish Mods The Caretakers.

Both Stephen and Quant were astute enough to consolidate on this celebrity, particularly through concessions in major international department stores. Paul Young, who was later to open his own New York boutique, Paraphernalia, brokered a deal between Quant and the giant JC Penney chain in the US. Stephen branded his firm as 'Carnaby Street' outside of Britain, with concessions at Stern Bros in New York, and in stores in a range of other cities, from Vancouver to Cape Town, and Amsterdam to Moscow. Each opening was a carefully stage-managed event that unashamedly used the full works of Swinging London iconography – Big Ben, red double-decker buses and phone boxes, black cabs, miniskirts and Mini cars. Perhaps the sweetest moment of this international campaign came with the opening of a 'Carnaby Street' boutique on the Via Margutta in Rome. Stephen was feted by the Roman glitterati, and the street blocked by crowds for the opening event. In the evening, Stephen's Rolls Royce drove through the Roman streets with an escort of scooters. This was, at least for a passing moment, a *sorpasso* of fashion in the city of *La Dolce Vita*; the man who had started out selling Italian-look suits in Carnaby Street was now hailed internationally as the epitome of style.

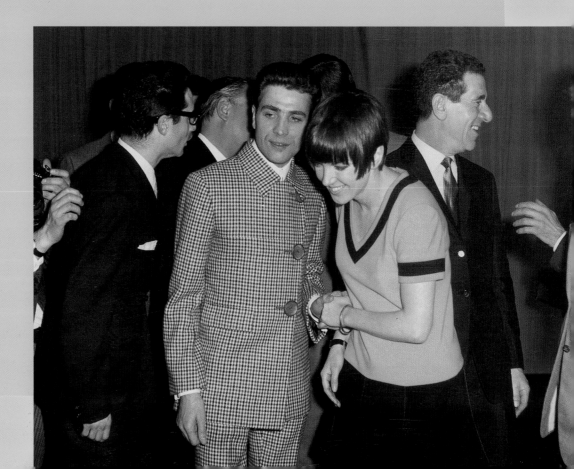

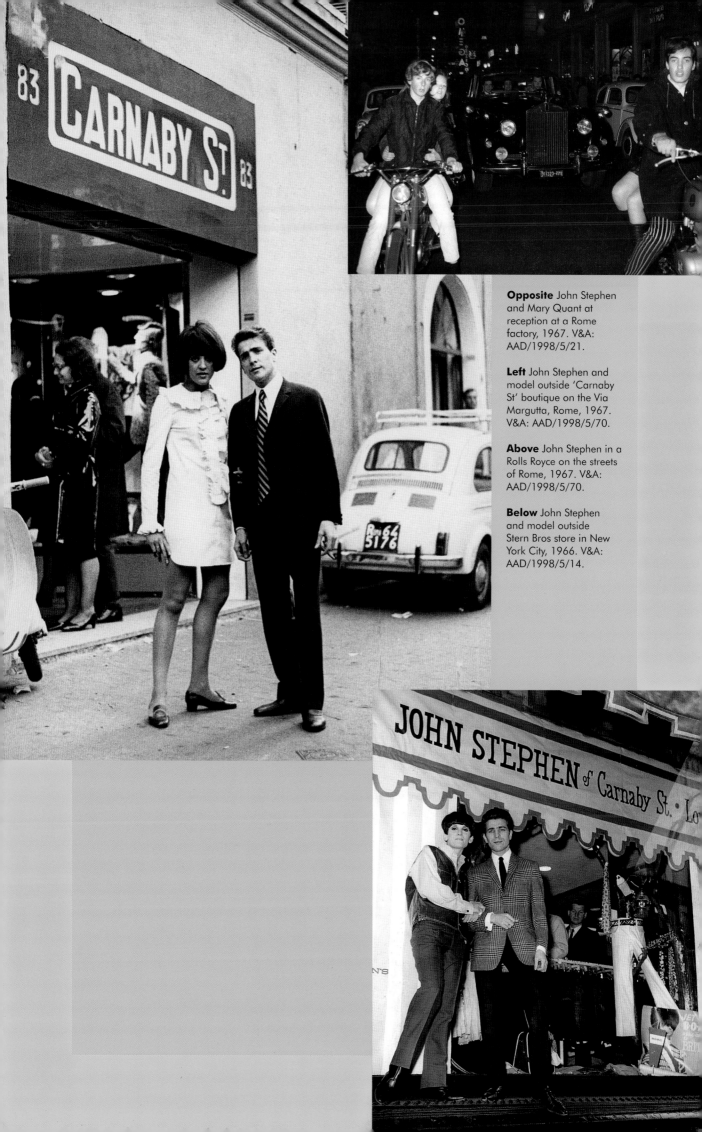

Opposite John Stephen and Mary Quant at reception at a Rome factory, 1967. V&A: AAD/1998/5/21.

Left John Stephen and model outside 'Carnaby St' boutique on the Via Margutta, Rome, 1967. V&A: AAD/1998/5/70.

Above John Stephen in a Rolls Royce on the streets of Rome, 1967. V&A: AAD/1998/5/70.

Below John Stephen and model outside Stern Bros store in New York City, 1966. V&A: AAD/1998/5/14.

Goodbye Baby and Amen

A POSTSCRIPT FOR THE SWINGING SIXTIES
CHRISTOPHER BREWARD

It will be a little time yet before the writers and sociologists, and all the other chart makers, get the age pinned down beneath the seismograph needles and make patterns that are not merely pretty, but enlightening. Meanwhile, we shall recall it with pleasure and fury and some sadness too... It was great fun. Sure.[1]

In their elegiac book of 1969, *Goodbye Baby and Amen: A Saraband for the Sixties*, David Bailey and Peter Evans provided an epitaph for the decade before it had even finished. Like *Time*'s 'Swinging London', the publication was an entirely self-referential project, immortalizing a metropolitan clique of models, actors, film-makers, restaurateurs, designers, writers, musicians and artists whose achievements somehow crystallized the aspirations and mood of an epoch. The authors themselves were very aware that the times they were aiming to record were actively mythologized through 'the molten fraud of commerce, and copywriters, and journalists, carried to the far corners of the earth by sexual fantasists who floated by in clouds of lavender coaches, like shy lovers in tunnels of love, unwilling

to admit disappointment.'[2] Some commentators were harsher in their evaluation of the decade, and certainly used less fantastical prose. Indeed *Goodbye Baby* was one of the more positive records of a moment that others had dismissed as delusional. As early as June 1966 *Queen* produced a response to *Time* under the dismissive banner 'Swingeing London'.[3] In *The Neophiliacs* Christopher Booker expanded on the theme of the Swinging Sixties as solipsistic nonsense, to be joined in his analysis a year later by fellow traditionalist Bernard Levin.[4] Yet, as the glamorous images and word-pictures of Bailey and Evans proved, there was still something sufficiently attractive and tangible about the 'Swinging' phenomenon to ensure that its myths would endure for much longer than its critics may have hoped.

Forty years on there is undoubtedly an irreducibility about surviving garments that challenges the ephemerality of the fashion photograph, the cinematic scenario or the literary confection – a presence that moves beyond the myth. A Mary Quant dress or a John Stephen suit makes an emphatic and embodied statement: 'I was designed, manufactured, bought and worn. I was there.'

The clothes of the period perhaps provide the most potent proof that the Swinging Sixties were an identifiable moment of real change and development, and not just a figment of the myth-maker's imagination. They are, above all else, concrete products of a new consumer-oriented economy where material benefits were more universally enjoyed than ever before.[5] And in their details and stylistic references they announce the flowering of a cultural and artistic renaissance that had important repercussions for the reformation of old hierarchies of taste and social behaviour and new understandings of city life.

Most importantly a reconsideration of the work of 1960s fashion designers, retail entrepreneurs and consumers themselves helps us to move beyond what historian Mark Donnelly has rather dismissively described as sterile debates about the myth or reality of the period. Thinking through the particular contexts in which new styles were produced and consumed, paying close attention to their material and visual qualities, pulls into focus the objects, images and ideas that contributed to the formation of such potent myths in the first place. This allows the historian to make

a more informed assessment of the reasons why different versions of the 1960s gained authority at particular times.[6] There is certainly a sense from this evidence that the Swinging Sixties never died, but simply offered subsequent generations a template for constant re-invention.

'Re-inventing the Sixties' would be a fitting theme for a future project, but for now it's worth indicating just two notable instances when the fashions and styles of the period have formed the basis of striking new interpretations.[7] In the late 1970s, invigorated by the licence Punk had provided to London's music and fashion entrepreneurs to cut up and reinterpret the pop-cultural past, New Wave bands such as The Jam and retailers such as Lloyd Johnson (who provided clothes for the 1978 film of The Who's *Quadrophenia*) pioneered a Mod revival. Carnaby Street and its environs enjoyed a fresh popularity as cult destination for a new generation of fashion followers, eager to purchase the tight mohair suits, button-down shirts and two-tone shoes that were now (erroneously) associated with the street in its mid-1960s heyday before the descent into pedestrianized banality and

Above 'Swingeing London',
Queen, 22 June 1966.

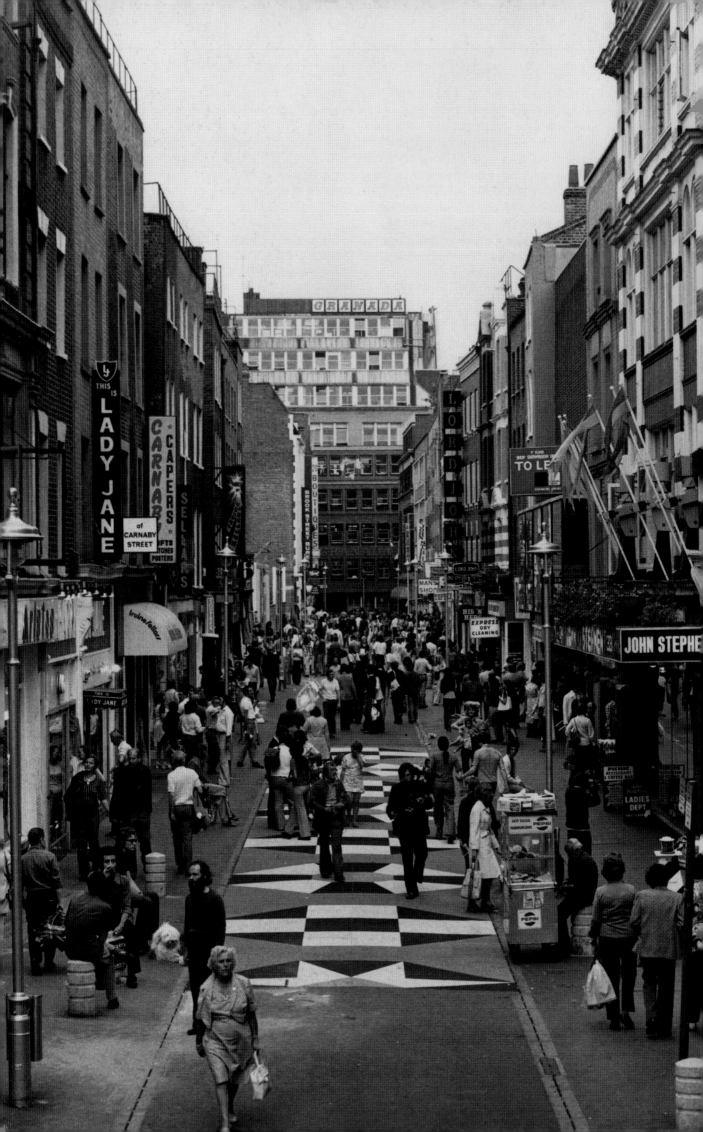

touristic kitsch.[8] And in March 1997 in a move that deliberately played on *Time*'s original reification of London as the epicentre of 'cool' in 1966, the American magazine *Vanity Fair* devoted a special issue to the ill-fated concept of 'Cool Britannia'. It informed readers that 'London Swings Again' while actress Patsy Kensit and rock star Liam Gallagher sprawled across the cover under a Union Jack duvet. Here the cocksure signifiers of 1990s 'Brit-pop' sat in uneasy alliance with the political optimism of a young Labour government, in much the same way that Quant and the Beatles were bracketed with Harold Wilson's aspirations for a newly dynamic Britain.

In the new century, no doubt the look of the 1960s will invite further retrospective glances. In the meantime, we hope that this current appraisal of its significance will encourage future approaches to the swinging theme that both acknowledge the myth and look to its deeper messages for future inspiration. London historian Roy Porter, himself a product of the 1960s, deserves the final word, for providing an analysis of the period's vibrancy that more than upholds Bailey and Evans's expectation of meaningful closure:

A culture materialized that was irreverent, offbeat, creative, novel. Politically idealistic …it broke through class-barriers and captured and transformed many of the better elements of traditional London: its cosmopolitanism and openness, its village quality, its closeness, its cocktail of talent, wealth and eccentricity. There was a rare alliance between youth culture and commerce, aristocratic style and a new populism. It was a breath of fresh air.[9]

Opposite Carnaby Street pedestrianized, c.1975.
© Getty Images.

NOTES

INTRODUCTION

1. *Time*, 15 April 1966, p.32
2. Booker (1969)
3. Moore-Gilbert and Seed (1992), p.3
4. Booker (1969), p.18
5. For a recent summary of key products and images of 'Swinging London' see Donnelly (2005) or Levy (2003).
6. Quant (1966), p.35
7. See Breward (2004) and Breward, Ehrman and Evans (2004) for pre-histories of London's fashion sector.
8. Donnelly (2005), p.95
9. Schmiechen (1984)
10. Sladen (1995)
11. De la Haye (1996)
12. See Fogg (2003)
13. See Amin and Thrift (2002), Appadurai (1990) and Gilbert (2000) for useful discussions of urban formations in relation to fashion culture.
14. Rycroft (2002)
15. See Cohn (1971) and Cole (2000) for the relationship between gay subcultures and the development of Carnaby Street.
16. O'Neill (2000), pp.487–506
17. Gorman (2001) and Osgerby (1998) both discuss the links between subcultural dressing and new forms of retail in interesting ways.
18. *Time*, 15 April 1966, p.42

KALEIDOSCOPE: FASHION IN SIXTIES LONDON

The designers pictured on p.23 are: Mary Quant; Alexander Plunket Greene; Marion Foale; Kiki Byrne; James Wedge; Sally Tuffin; Gerald McCann; Jean Elizabeth Muir; David Sassoon and Kenneth Sweet.
1. Quant (1966), p.74
2. For further details on couture dressmaking in London see Edwina Ehrman (2004), Edwina Ehrman (2002), Amy de la Haye (2002), Marion Hume (1996) and Lou Taylor (1996).
3. Hulanicki (1983), p.62
4. *Queen*, 2 February 1960
5. See Christopher Breward (2003), pp.190–213, Paul Gorman (2001) and Ted Polhemus (1994).
6. See Paul Gorman (2001) and Hebdige (1988), pp.109–12.
7. Quant (1966), pp.76–7
8. Barnes (1979), p.10
9. Johnson (1967), p.50
10. Quant (1966), p.35
11. See Janey Ironside (1962, 1963 and 1973).
12. See Sylvia Ayton (2005), pp.117–27, for an account of training at the RCA and working as a designer in the 1960s.
13. *Vogue*, 15 October 1966, pp.124–29
14. See Lobenthal (1990) and Pierre Cardin exhibition catalogue (1990).
15. Rowbotham (2000), pp.119–20
16. The example given, a Mary Quant Ginger Group dress, similar to plate 2, is illustrated in *Vogue*, September 1967, p.106. I am grateful to Lynda Hillyer for first-hand information about being a consumer of fashion in London in the late 1960s and early 1970s.
17. Pringle (1988), pp.37–8. See also Tyne and Wear Museums (1993) and Turner (2004).
18. See Watt (2003).
19. Bennett-England (1967), p.92
20. *Vogue*, May 1964, p.122

'BRAVE NEW LONDON': ARCHITECTURE FOR A SWINGING CITY

1. *Sunday Times Magazine*, 1 April 1962, p.15
2. Ackroyd (2001), p.753
3. *Guardian*, 15 April 1966
4. Rappaport (2002)
5. 'Living with the motor car', *Sunday Times*, 24 November 1963, p.9
6. *Sunday Times Magazine*, 1 April 1962, p.15
7. Carter (1962), p.13
8. Quant (1966), p.134
9. *Time*, 15 April 1966, p.41
10. Ackroyd (2001), p.760
11. 'The Plug-In city', *Sunday Times*, 20 September 1964, p.33
12. Jackson (1998), pp.198–202
13. Text accompanying Archigram, 'Instant City' exhibition panel, 1969 (Prints circ 472–1972)
14. 'The Plug-In city', *Sunday Times*, 20 September 1964, p.29
15. *Drapers' Record*, 3 December 1966, p.7
16. Kenneth Browne, 'A Latin Quarter for London', *Architectural Review*, (March 1964), p.193
17. Ibid., pp.196–7

'I THINK THEY'RE ALL MAD': SHOPPING IN SWINGING LONDON

1. *Time*, 15 April 1966
2. Aitken (1967), p.18
3. Bultitude (1966), p.vii
4. Winship (2000)
5. *Vogue*, January 1950
6. Glynn, *The Times*, 23 September 1966
7. 'The London Way', *Vogue*, February 1950, p.77
8. *Drapers' Record*, 18 October 1958, p.1
9. 'The Teenage Thing', *Vogue*, December 1959
10. Morgan, *New Statesman*, 26 November 1965
11. Baker, *Nova*, September 1969
12. Quant (1966), pp.43–4
13. Ayton (2005)
14. Quant (1966), p.46
15. See for instance, Cossack vodka advertisement, *Sunday Times Magazine*, 15 November 1964.
16. See Christopher Breward's analysis of the 'dolly bird' (2004), pp.151–76, and Pamela Church Gibson's chapter in this book.
17. O'Neill (2000)
18. 'Lynda Lee-Potter meets Mr. Carnaby and his £1000 teeth', *Daily Mail*, c.August 1968
19. Aitken (1967), p.30
20. Ibid., pp.18–19
21. Lawson (1997), p.33
22. Brittain, *Investors Chronicle*, 28 January 1966
23. Morgan, *New Statesman*, 26 November 1965
24. Baynes, *Design*, August 1966, no.212
25. Hughes-Stanton, *Design*, February 1968, no.280
26. *Drapers' Record*, passim
27. Glynn, *The Times*, 6 June 1967
28. Flack, c.1989 (Courtesy Harrods Archive)
29. Black, *Financial Times*, 9 June 1966
30. *Glasgow Herald*, 1 March 1966
31. Fraser, *New Yorker*, 18 February 1974
32. Ibid.
33. Turner (2004), p.80
34. The store was successfully evacuated, although damage was done to the basement.
35. *Drapers' Record*, 8 May 1971, p.5

MYTHS OF THE SWINGING CITY

1. *The Times*, 1 July 1968
2. *Sunday Times Magazine*, 4 February 1962
3. Harrison (1999)
4. *Sunday Times Magazine*, 10 May 1964
5. Ibid.
6. Ibid.
7. Lawson & Denning (1997)
8. Bennett (1999), pp.77–81
9. Ibid.
10. Rojek (2001)
11. Rous (1999), p.xxi
12. Murphy (1992)
13. Geraghty, in Murphy (ed.), (2001)
14. Walker (1974)
15. Church Gibson and Hill in Murphy (ed.), (2001)
16. Miller (1999)
17. Marwick (1998)
18. Green (1999)
19. Thatcher quoted in Levinhas (1988), p.55
20. Tebbit quoted in Jenkins (1987), p.326

OUT OF LONDON

1. Sandi Stewart, ninth-grade American Beatles fan interviewed in 1966 in Davis (1985), p.265
2. Gorman (2001), p.36
3. Chenoune (1993), p.276
4. *The Outfitter*, 11 January 1964, p.7
5. See Green (1998)
6. Breward (2003), p.87
7. Mendes and de la Haye (1999), p.169
8. Lobenthal (1990), pp.100–01
9. Chenoune (1993), p.268
10. Ibid., p.271
11. Lobenthal (1990), pp.78–9
12. Green (1997), p.120
13. Quant (1966), p.73
14. Colin Woodhead of Austin Reed, quoted in Gorman (2001), p.60
15. *Sunday Times Magazine*, 27 March 1966
16. Fairley (1969), p.45
17. Wynn-Jones (1966), pp.22–7
18. John Stephen papers, press cuttings, Victoria and Albert Museum, Archive of Art and Design, AAD/1998/5
19. Hulanicki (1983), pp.71–3
20. Fogg (2003), p.141
21. *Drapers' Record*, 30 September 1967, p.14

'GOODBYE BABY AND AMEN': A POST-SCRIPT FOR THE SWINGING SIXTIES

1. Bailey and Evans (1969), p.237
2. Ibid., p.10
3. The title 'Swingeing London' would also be used by the pop artist Richard Hamilton for his collage of 1968 commemorating the famous Rolling Stones' drugs trial.
4. Booker (1969) p.308, and Levin (1970) pp.186–7
5. Donnelly (2005), p.195
6. Ibid., pp.196–7
7. For academic considerations of the cultural and economic impact of the Sixties, see Cairncross (1992) and Moore-Gilbert and Seed (1992).
8. Gorman (2001), p.142
9. Porter (1994), p.363

BIBLIOGRAPHY

Ackroyd, Peter. *London: The Biography* (London, 2001)

Aitken, Jonathan. *The Young Meteors* (London, 1967)

An Aid to Pedestrian Movement: A Report by a Working Party on The Introduction of a New Mode of Transport in Central London, Westminster City Council, March 1971

Amin, Ash, and Nigel Thrift. *Cities: Reimagining the Urban* (London, 2002)

Appadurai, Arjun. 'Disjuncture and difference in the global culture economy', *Theory, Culture, and Society* (1990), vol.7. pp.295–310

Ayton, Sylvia. 'A Love-Hate Relationship with Couture', *Costume* (2005), vol.39, pp.117–27

Bailey, David, and Peter Evans. *Goodbye Baby and Amen: A Saraband for the Sixties* (London, 1969)

Baker, Caroline. 'Here is the news from the London Collections', *Nova* (September 1969), pp.56–7

Barnes, Richard. *Mods!* (London, 1979)

Baynes, Kate and Ken. 'Behind the Scene', *Design* (August 1966), no.212, pp.19–29

Bennett England, Rodney. *Dress Optional: The Revolution in Menswear* (London, 1967)

Bennett, Alan. *Writing Home* (London, 1999)

Beyfuss, Drusilla. 'How to Tell a Boy From a Girl', *Sunday Times Magazine* (20 September 1964)

Bishop, James and Oliver Woods. *The Story of the Times* (London, 1983)

Black, Sheila, 'Carnaby Street – London's £5m a Year Quarter Mile', *Financial Times* (9 June 1966)

Booker, Christopher. *The Neophiliacs: A Study of the Revolution in English Life in the Fifties and Sixties* (London, 1969)

Breward, Christopher. *Fashion* (Oxford, 2003)

Breward, Christopher. 'Style and Subversion: Postwar Poses and the Neo-Edwardian Suit in Mid-Twentieth Century Britain', in Burman and Turbin (ed.), *Material Strategies – Dress and Gender in Historical Perspective* (Oxford, 2003), pp.190–213

Breward, Christopher. *Fashioning London: clothing and the modern metropolis* (Oxford, 2004)

Breward, Christopher, Becky Conekin and Caroline Cox. *The Englishness of English Dress* (Oxford, 2002)

Breward, Christopher, Edwina Ehrman and Caroline Evans. *The London Look: fashion from Street to Catwalk* (London, 2004)

Brittain, Victoria. 'Success and Carnaby Street', *Investors Chronicle* (28 Jan 1966).

Bultitude, Millicent. *Get Dressed: A Useful Guide to London's Boutiques* (London, 1966)

Burman, Barbara and Carol Turbin. *Material Strategies: Gender, Dress and Material Culture* (Oxford, 2003)

Cairncross, F. and A. Cairncross (eds). *The Legacy of the Golden Age: The 1960s and their economic consequences* (London, 1992)

Carter, Edward. *The Future of London* (Harmondsworth, 1962)

Carter, Ernestine. 'Into the Big Time', *Sunday Times Magazine* (4 February 1962)

Chenoune, Farid. *A History of Men's Fashion* (Paris, 1993)

Church Gibson, Pamela and Andrew Hill. 'Tutte e marchio: excess, masquerade and performativity in seventies British cinema' in Murphy, Robert (ed.), *The British Cinema Book* (London, 2001)

Cohn, Nic. *Today there are no Gentlemen* (London, 1971)

Cole, Shaun. *Don We Now Our Gay Apparel: Gay Men's Dress in the Twentieth Century* (Oxford, 2000)

Davis, Hunter. *The Beatles* (London, 1985)

De la Haye, Amy. *The Cutting Edge: 50 Years of British Fashion 1947–1997* (London, 1996)

De la Haye, Amy. 'Gilded Brocade Gowns and Impeccable Tailored Tweeds: Victor Stiebel (1907–76) a Quintessentially English Designer', in Breward, Conekin and Cox (eds), *The Englishness of English Dress* (Oxford, 2002)

Donnelly, Mark. *Sixties Britain* (London, 2005)

Ehrman, Edwina, 'Broken Traditions: 1930–55' in Breward, Ehrman and Evans (eds), *The London Look – fashion from street to catwalk* (London, 2004), pp.97–115

Ehrman, Edwina, 'The Spirit of English Style: Hardy Amies, Royal Dressmaker and International Businessman' in Breward, Conekin and Cox (eds), *The Englishness of English Dress* (Oxford, 2002)

Fairley, R. *A Bomb in the Collection: Fashion with the Lid Off* (Brighton, 1969)

Farr, Michael. *Design in British Industry: A mid-century survey* (Cambridge, 1955)

Flack, Tony. 'A Personal History of Way In Boutique', Harrods Archive, c.1989.

Fogg, Marnie. *Boutique. A '60s Cultural Phenomenon* (London, 2003)

Fraser, Kennedy. 'Biba', *New Yorker* (18 February 1974)

Geraghty, Christine. 'Women and sixties British cinema: the development of the "Darling" girl' in Murphy, Robert (ed.), *The British Cinema Book* (London, 2001)

Gilbert, David. 'Urban Outfitting: The City and the Spaces of Fashion Culture' in S. Bruzzi and P. Church-Gibson (eds), *Fashion Cultures* (London, 2000)

Glynn, Prudence. 'Boutiques – or what you will', *The Times* (23 September 1966)

Glynn, Prudence. 'Harrods through the keyhole', *The Times* (6 June 1967)

Gorman, Paul. *The Look. Adventures in Pop and Rock Fashion* (London, 2001)

Green, Jonathan. *Days in the Life: Voices from the English Underground 1961–1971* (London, 1998)

Green, Nancy. *Ready to wear and ready to work* (Durham, 1997)

Harrison, Martin. *David Bailey: The Birth of Cool 1957–1969* (London, 1999)

Hebdige, Richard. *Hiding in the Light: On Images and Things* (London, 1988)

Hughes-Stanton, Corin. 'What Comes after Carnaby Street?', *Design* (February 1968) no.280, pp.42–3

Hulanicki, Barbara. *From A to Biba* (London, 1983)

Hume, Marion. 'Tailoring', in de la Haye, Amy (ed.), *The Cutting Edge* (London, 1996), pp. 36-61

Ironside, Janey. *A Fashion Alphabet* (London, 1968)

Ironside, Janey. *Fashion as a Career* (London, 1962)

Ironside, Janey. *Janey: An Autobiography* (London, 1963)

Jackson, Leslie. *The Sixties: Decade of Design Revolution* (London, 1998)

Johnson, David. *Gear Guide* (London, c.1967)

Lawson, Twiggy. *Twiggy in Black and White* (London, 1997)

Levy, Shawn, *Ready Steady Go: Swinging London and the Invention of Cool* (London, 2002)

Lobenthal, Joel. *Radical Rags: Fashions of the Sixties* (New York, 1990)

Marwick, Arthur. *The Sixties: Cultural Revolution in Britain, France, Italy and the United States* (Oxford, 1998)

Mendes, Valerie and de la Haye, Amy. *20th-Century Fashion* (London, 1999)

Mendes, Valerie. *Pierre Cardin: Past Present Future* (London and Berlin: Dirk Nishen Publishing, 1990)

Miller, Toby. *The Avengers* (London, 1999)

Ministry of Transport. *Traffic in Towns* (Harmondsworth, 1964)

Moore-Gilbert, B., and J. Seed (eds), *Cultural Revolution? The Challenge of the Arts in the 1960s* (London, 1992)

Morgan, John. 'Males in Vogue', *New Statesman* (26 November 1965)

Murphy, Robert. *Sixties British Cinema* (London, 1992)

Osgerby, Bill. *Youth in Britain Since 1945* (Oxford, 1997)

O'Neill, Alistair. 'John Stephen: A Carnaby Street Presentation of Masculinity 1957–1975.' *Fashion Theory* (2000), vol.4, pp.487–506.

Polhemus, Ted. *Streetstyle* (London, 1994)

Porter, Roy. *London: A Social History* (London, 1994)

Pringle, Alexandra, 'Chelsea Girl' in Sara Maitland ed., *Very Heaven: Looking back at the 1960s* (London, 1988)

Quant, Mary. *Quant by Quant* (London, 1966)

Rappaport, Erika, 'Art, Commerce, or Empire? The Rebuilding of Regent Street, 1880–1927', *History Workshop Journal* (2002), vol.53, pp.94–117

Rojek, Christopher. *Celebrity* (London, 2001)

Rous, Henrietta (ed.), *The Ossie Clark Diaries* (London, 1999)

Rowbotham, Sheila. *Promise of a Dream: Remembering the Sixties* (London, 2000)

Rycroft, Simon 'The Geographies of Swinging London', *Journal of Historical Geography* (2002), vol.28, pp.566–88

Schmiechen, J., *Sweated Industries and Sweated Labour: The London Clothing Trades 1860–1914* (Urbana, 1984)

Sladen, Christopher. *The Conscription of Fashion: Utility Cloth, Clothing and Footwear 1941–1952* (Aldershot, 1995)

Taylor, Lou. 'Romantic', in de la Haye, Amy (ed.), *The Cutting Edge* (London, 1996), pp.62–91

Turner, Alwyn. *The Biba Experience* (Woodbridge, 2004)

Tyne and Wear Museums. *Biba – The Label: The Lifestyle: The Look*, (Newcastle, 1993)

Walker, Alexander. *Hollywood, England: The British Film Industry in the Sixties* (London, 1974)

Watt, Judith. *Ossie Clark 1965–74* (London, 2003)

Wyndham, Francis. 'The Photographers', *Sunday Times Magazine* (10 May 1964)

Wynn-Jones, Michael. 'Britain – No Mod Cons', *Nova* (August 1966), pp. 22–7

INDEX

Adam (shop) 65
An Aid to Pedestrian Movement 46, *46*
Alfie 8
Ambassador 57
Amies, Hardy 22
Angry Brigade, 'Communiqué 8' 74
Annabel's 20
Annacat 66, *66*
Antonioni, Michelangelo 52, 95
Apple boutique 78
Archigram 51-2, 51
Architectural Review 52, 55
Armstrong-Jones, Antony 87
Asher, Jane *88*, 100
Aspinall, Jack 20
Austin Reed 69, 70
The Avengers 30, 95
Ayton, Sylvia 30, 62

Bailey, David 20, 85, 87, 95, 100
 and Evans, Peter, *Goodbye Baby and
 Amen: A Saraband for the Sixties* 120, 123
Baker, Caroline 97
Banks, Jeff 66, 92
Bara, Theda 97
Barnes, Richard 25-6
Barok 78
Bates, John 14, 30, *31*, 95
Baynes, Kate and Ken 69-70
Bazaar 15, 26-9, *26*, 31, 61, 62, *63*,
 69, 78
Beardsley, Aubrey 31
Beatle jackets 94, 102-5
The Beatles 38, 78, 91, 94, 100, 102-5,
 103, 118, 123
Beaton, Sir Cecil 91, 100
Beatty, Warren 21, *93*
Bender, Lee 66
Best, George *118*
Beyond the Fringe 91
Biba 15, 31-4, 52, 55, 62, 66, 68, 74,
 74, *75*, 78, *78*, 79, 114
Billy Liar 95, 117
Birdcage 117
Birkin, Jane 52
Birtwell, Celia 34, *34*, 52, *88*, *89*, 100
Blackburn, Tony 94
Black, Cilla 92
Black Dwarf 97
Blackman, Honor 95
Blades 36, 38, 66
Blake, Peter 94
'Blow-Out City' 52
Blow-Up 52, 95
Bond Street 45, 58
Booker, Christopher 12
 The Neophiliacs 51, 56, 120
Booth, Pat 66
Bootique 76
Boshier, Derek 78
Bourne & Hollingsworth 61
Bowyer, Jackie *41*
Boxer, Mark 80
Boyd, Patti 82, 91-2
Boyfriend 62
Bradford, Rose 69
Brando, Marlon 20
Bravo 112
Browne, Kenneth 52-5
Buchanan, Colin, *Traffic in Towns* 46
Burtons 25
Bus Stop 66
Butterick 117
Byrne, Kiki 29

Caine, Michael 20, 69, 94, 95
Cardin, Pierre 31, 34, 95, 102, *104*, 111
 'Cosmos' outfit 34, 35, 106, *106*
The Caretakers 118
Carnaby Street 16-20, *17*, 25, 26, 31,
 46, 51, 55, 62, 65, 66, 69-74, 78,
 92, 112, *112*, 114-17, 118, 121, *122*
Caron, Leslie 21
Carter, Edward 48

Carter, Ernestine 40
Cathy Come Home 96
Cecil Gee 102
Centre Point 45, 48
Chaillet, Catherine 57
Chanel, Coco 40
Charles, Caroline 29
Chelsea Girl 111
Christie, Julie 94, 95
Christie's 16
Clapton, Eric 92
Clark, Ossie 14-15, 34, *34*, 52, 62, 65,
 66, *88*, 92, 95
Clobber 66, 78, 92
Clore, Charles 73
Cook, Peter (architect) 51
Cook, Peter (comedian) 91
'Cool Britannia' 123
Corbetta, Gigi *112*
Cosmopolitan 97
Countdown 66, 70, 78
Courrèges, André 31
 Space Age collection *88*, *89*, 106
Courtenay, Tom 95
Covent Garden 45, 52, 55
Cowan, John 57
Creed, Charles 59
Cressy, Simon 109
Crisis (charity) 96
Cue 69
Curtis, Tony 69

Darling 95
Denny, Robyn 70-3
Denza, Vanessa 70
Derry and Toms 74, 75
Design 69, *69*
de Villeneuve, Justin (Nigel Davies) 75,
 88-91
D. H. Evans 73
Dickinson, Geoffrey 8, 9, 12
Digby Morton 44
Dior, Christian 40
 'New Look' 110
Dispo, paper dresses 53
Domus magazine 12
Donnelly, Mark 121
Donovan, Terence 87, 100
Drapers' Record 52, 117
Drew, Diana 109
Duffy, Brian 87, 100
Dylan, Bob 74

Erik 40

Faithfull, Marianne 92, 94
Farleigh, John 46
Fashion House Group of London 112
Finney, Albert 95
Fish, Michael 38
Fitz Simon, John 31
Foale, Marion, and Tuffin, Sally 14, 16,
 30, 32-3, 62, 70, 78, 79, *91*, *93*, 95
Fonteyn, Margot 21
Fordham, Pauline 20, 70
Forward Look 109
Fox, James 97
Franks, Lynne 84, 100
Fraser, Robert 20
Fratini, Gina 29
French, John 87, 100
Frye, Madeline 70
Fulham Road Clothes Shop 62

Gallagher, Liam 123
Gay News 97
Georgy Girl 95
Gernreich, Rudi 88, 100, 109
Ginger Group 31, 40, 60, *61*, 82
Glass and Black 29
Glynn Smith, Juliet 73
Gold, David 26
Gold, Warren 26, 73
Goldsmith's College of Art 26

Granny Takes a Trip 66, 69, 78
Green, Bill 65
Green, Felicity 91
Gurley Brown, Helen 97
Guy's and Doll's 20

Hamilton, Richard 15
Harper's Bazaar 26
Harrison, George 91
Harrods 62
 Way In 73, 78
Hartnell, Norman 22
Haywood, Doug 20
Hemmings, David 95
Hendrix, Jimi 94
Heron, Ron, *Instant City* 51, 52
Hills, Gillian 52
His Clothes 25, 26, 65
Honey 61, 80-3, 95
Hornby, Charley 38
Hornby, Helen *81*
Horrockses 22, 24
Hulanicki, Barbara 22, 31-4, *34*, 55,
 62, 65, 66, 68, 74, 79
Hung On You 16, 66, 67, 77, 79

Incorporated Society of London Fashion
 Designers 15
Independent Group 15
Ironside, Janey 29
I Was Lord Kitchener's Valet 70, *71*

Jaeger 22, 73
Jagger, Bianca 34
Jagger, Mick 20, 94, 95
The Jam 121
Jane and Jane 29
Jean Varon 30
John Michael 78, 102
Johnson, Lloyd 121
Jones, Brian 94
Joseph, Leonard 109
Jump Ahead boutique 52
Just Looking 66

Kaleidoscope 93, 95
Kensit, Patsy 123
Kingsford, Sue 20
King's Road 16, 20, 26, 31, 51, 61,
 66, 69, 95
'Kinky Boots' 95
The Knack 95
Knightsbridge 58
Kray brothers 95

'Layla' 92
Lennon, John 12
Leonard 88-91
Levin, Bernard 120
Liberty 29, 30
London Museum 40
Lord John 26, *26*, 73
Lulu 92
Lycett Green, Rupert 36, 38

McCann, Gerald 29, 30, *30*, 78, 117
McCartney, Paul 91
McConnell, John 78
McDowell, Roddy 20
McGowan, Cathy 20, 88, 92, 94, 100
McLaren, Malcolm 77, 79
McNair, Archie 26, 61, 111
Macnee, Patrick 95
Male West One 65
The Man's Shop 65
Margaret, Princess 87
Melody Maker 114
Men in Vogue 97
Millings, Dougie 102, *104*
minet style 109
miniskirt 40, 52, 88, 92, 106
Mirandi, jerkin 67
Miss Selfridge 73, 111
Mlinaric, David 38